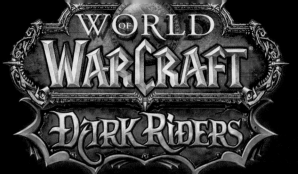

WRITER:
MIKE COSTA

ARTIST:
NEIL GOOGE

COLORISTS: PIERRE MATTERNE, LEE LOUGHRIDGE & LEN O'GRADY

LETTERER: WES ABBOTT

STORY CONSULTANTS: CHRIS METZEN, ALEX AFRASIABI,
LUIS BARRIGA & MICKY NEILSON

COVER: ALEX HORLEY & SAMWISE DIDIER

SPECIAL THANKS TO JOSHUA HORST

WORLD OF WARCRAFT: DARK RIDERS

Library of Congress Cataloging-in-Publication Data

Costa, Mike, author.
World of Warcraft : Dark Riders / Mike Costa, Neil Googe.
pages cm
ISBN 978-1-4012-3027-2
1. Graphic novels. I. Googe, Neil, illustrator. II. Title. III. Title: Dark Riders.
PN6728.W69C67 2013
741.5'973--dc23
2012050101

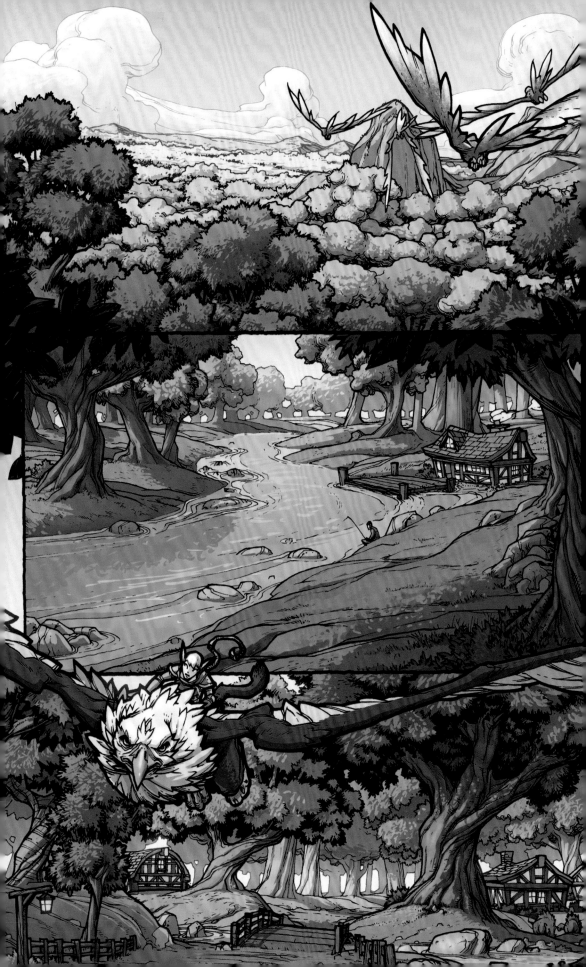

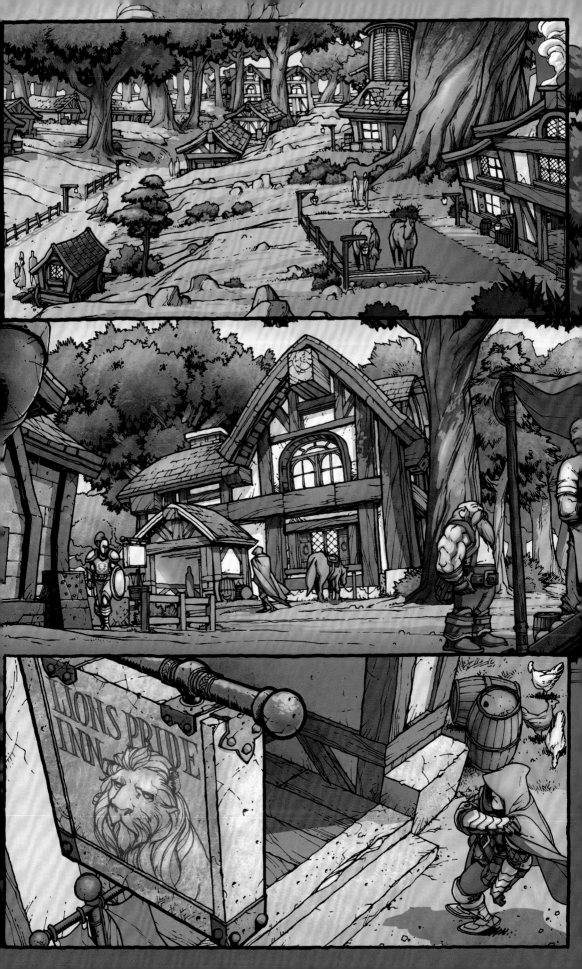

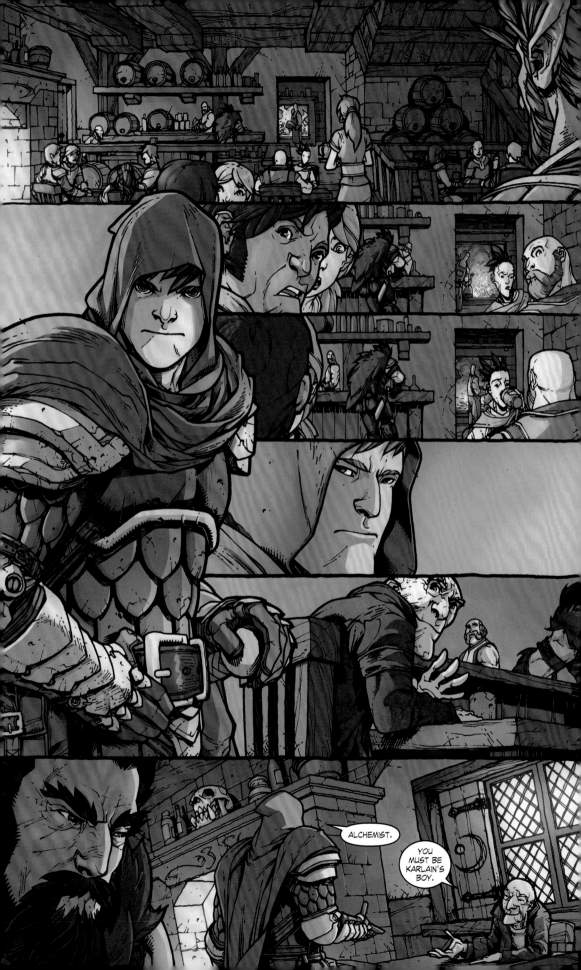

ALCHEMIST.

YOU MUST BE KARLAIN'S BOY.

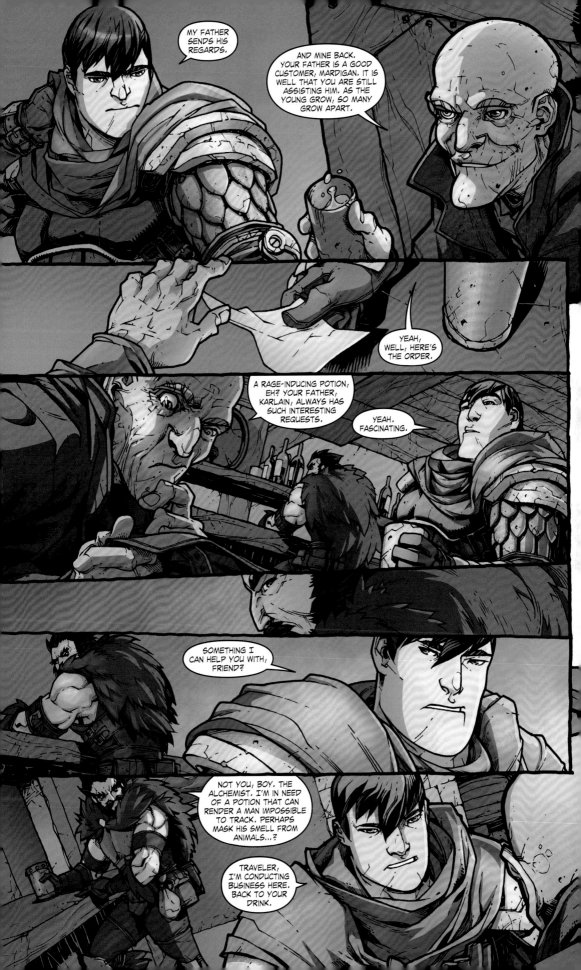

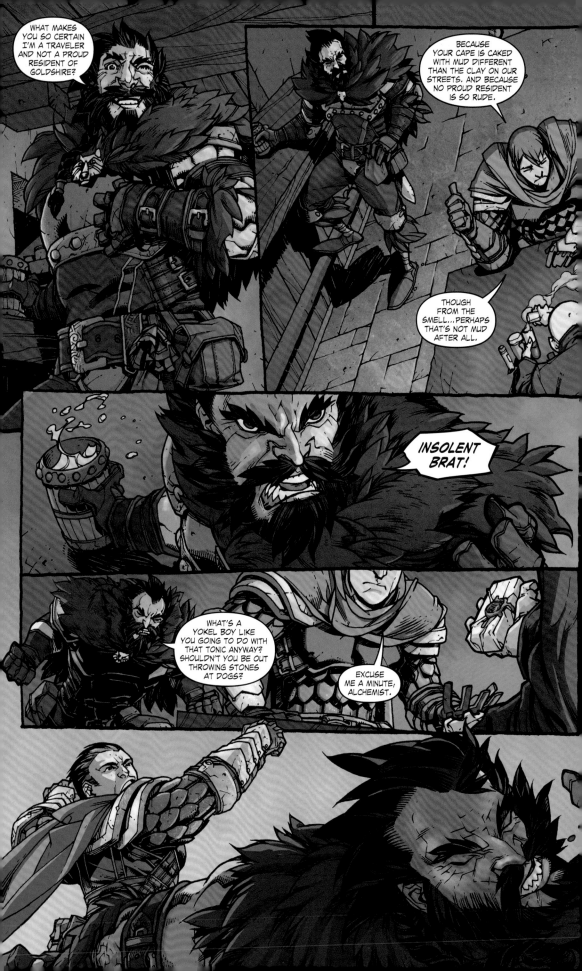

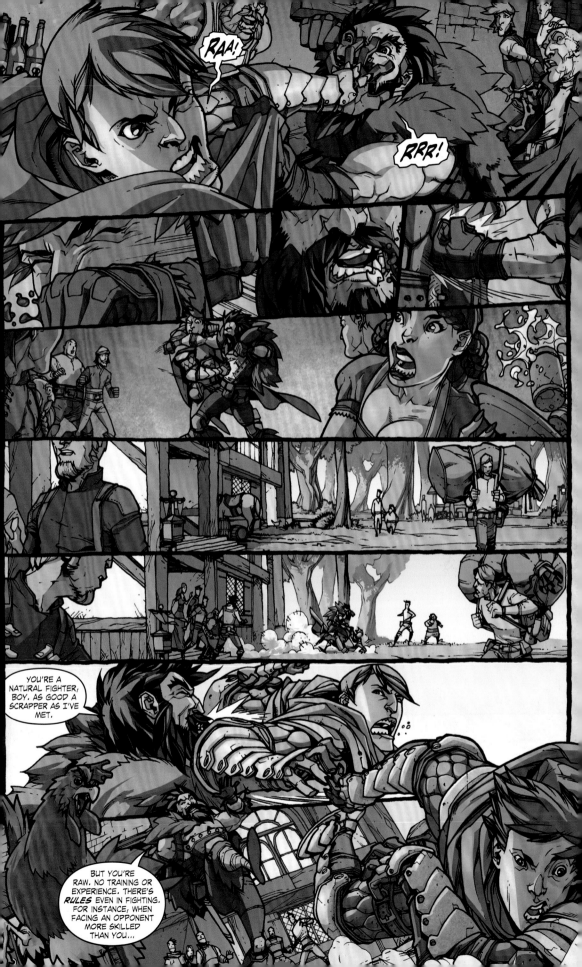

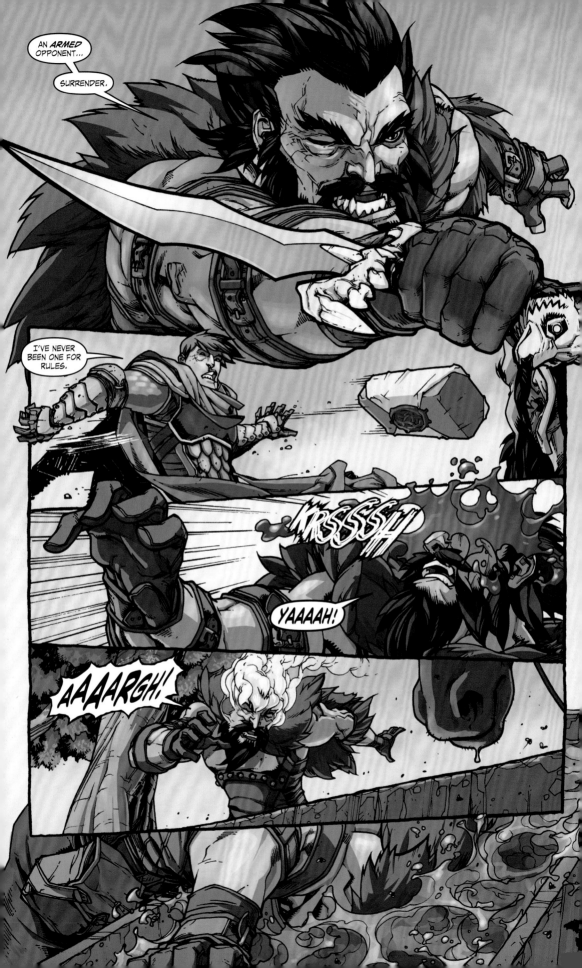

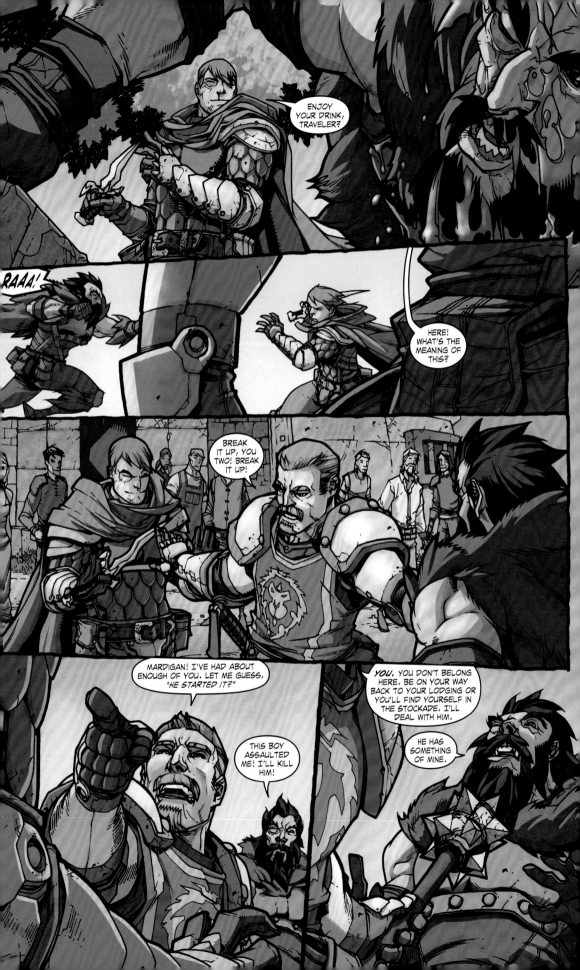

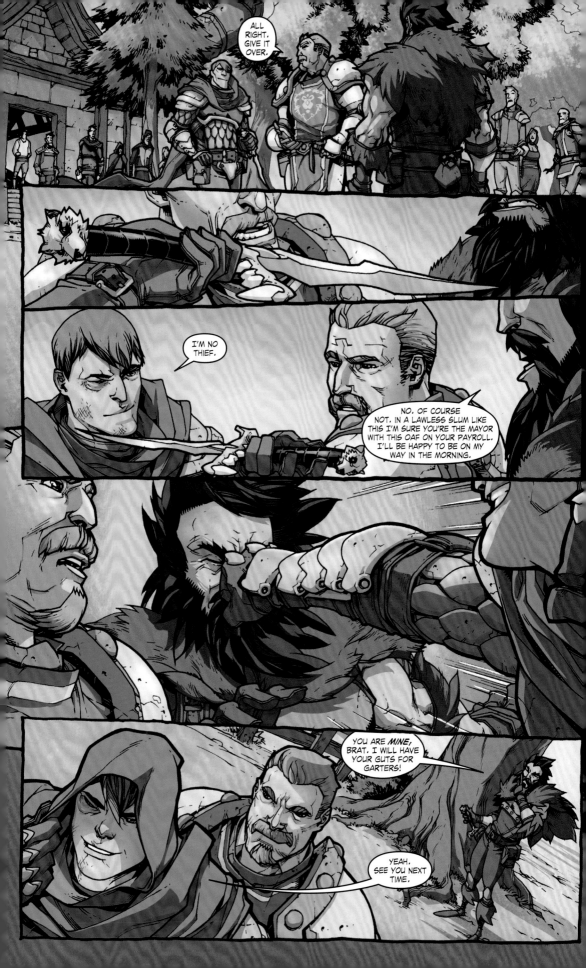

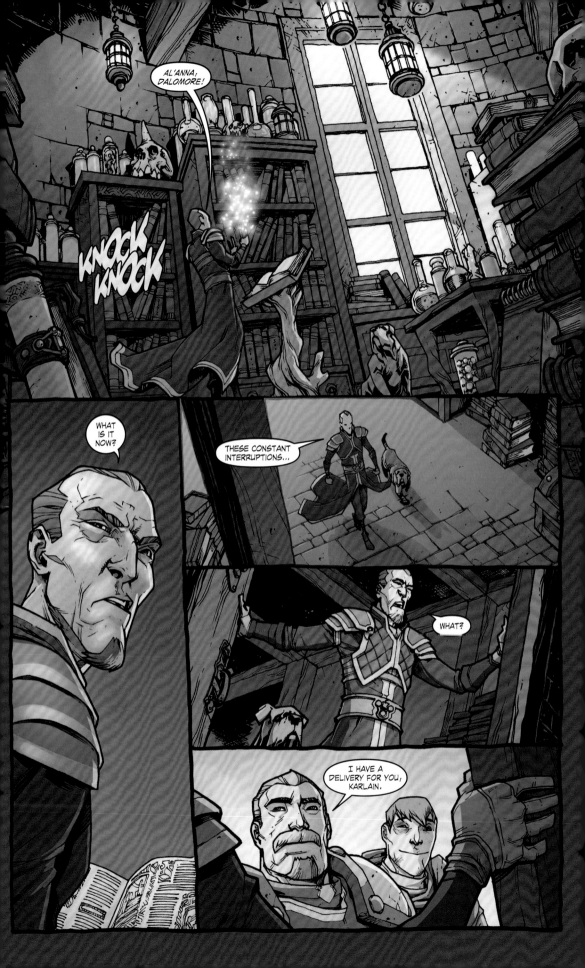

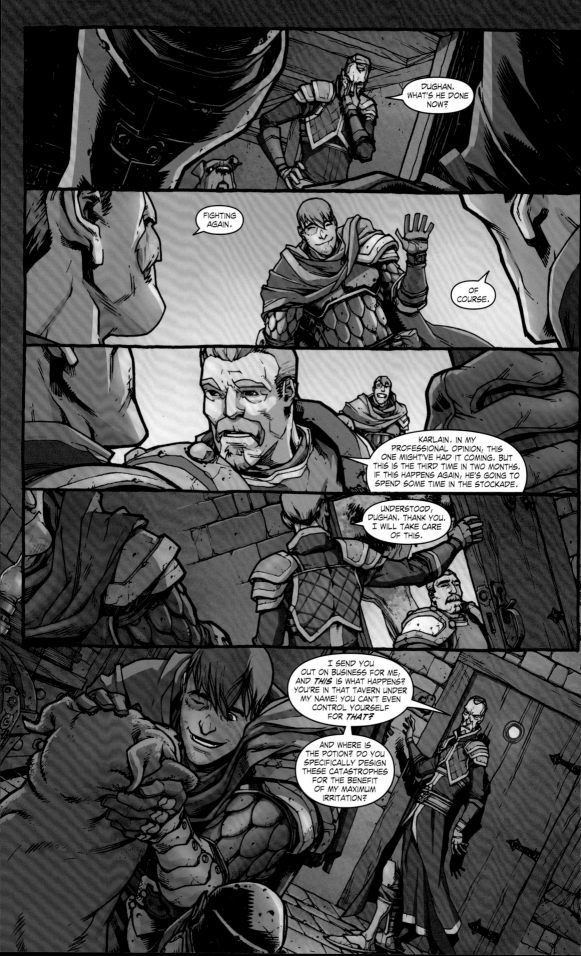

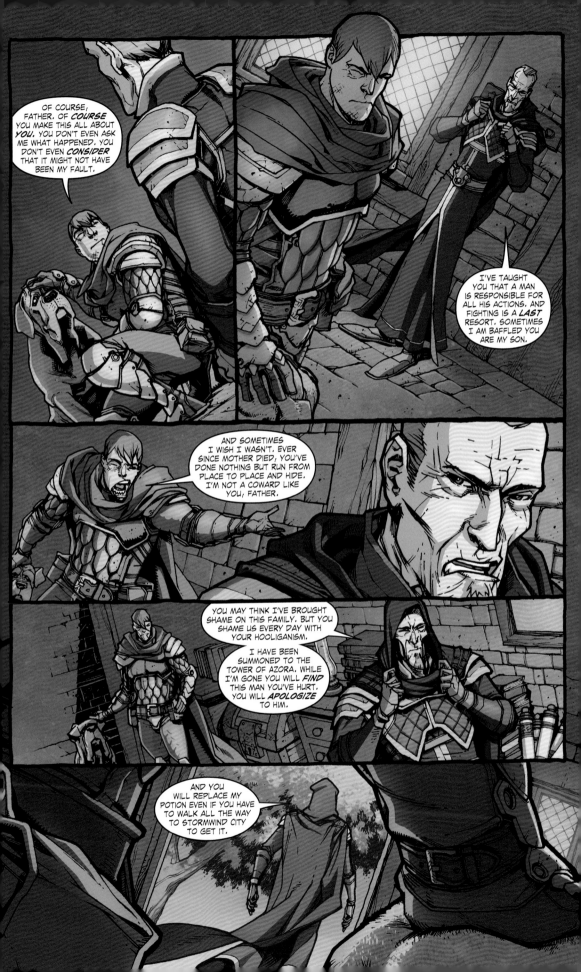

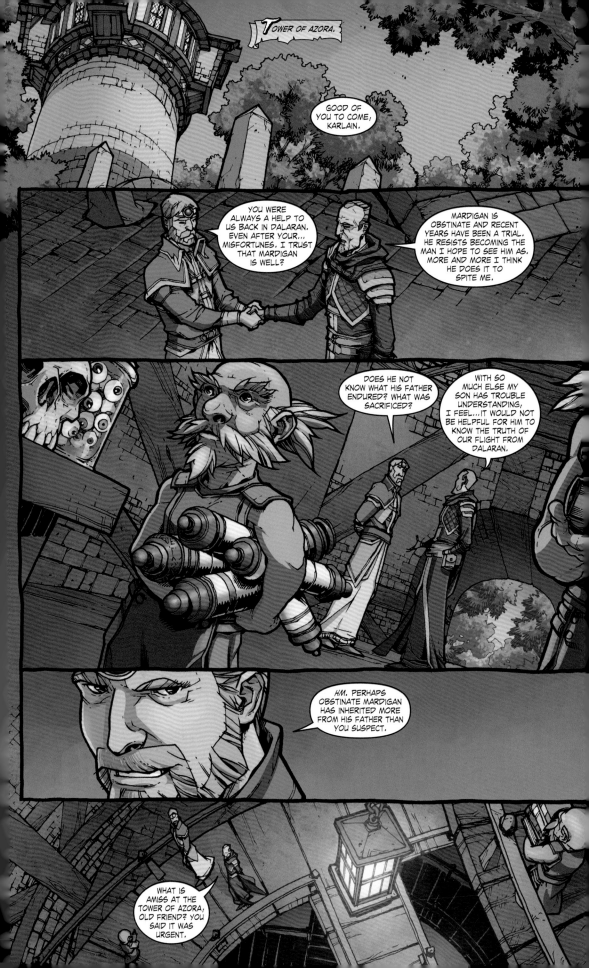

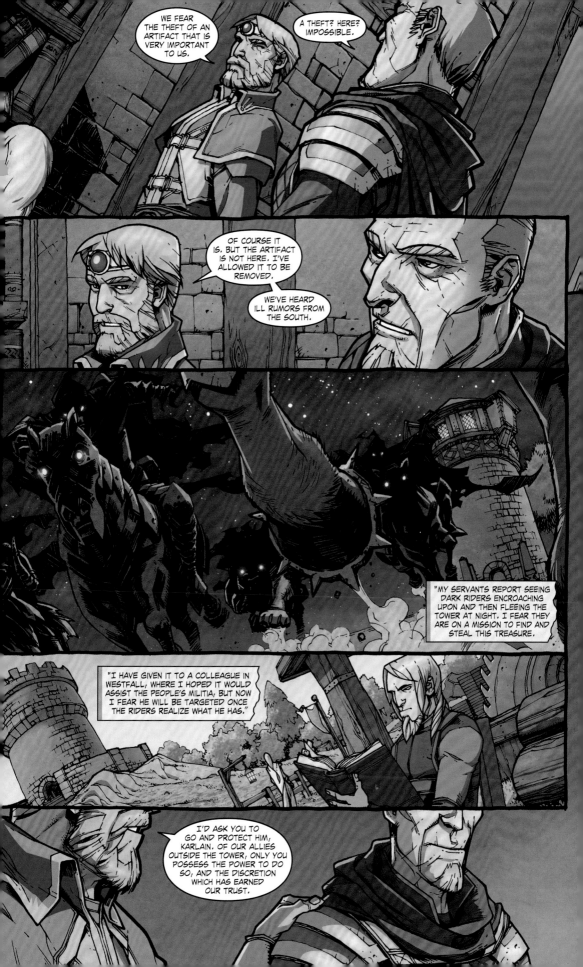

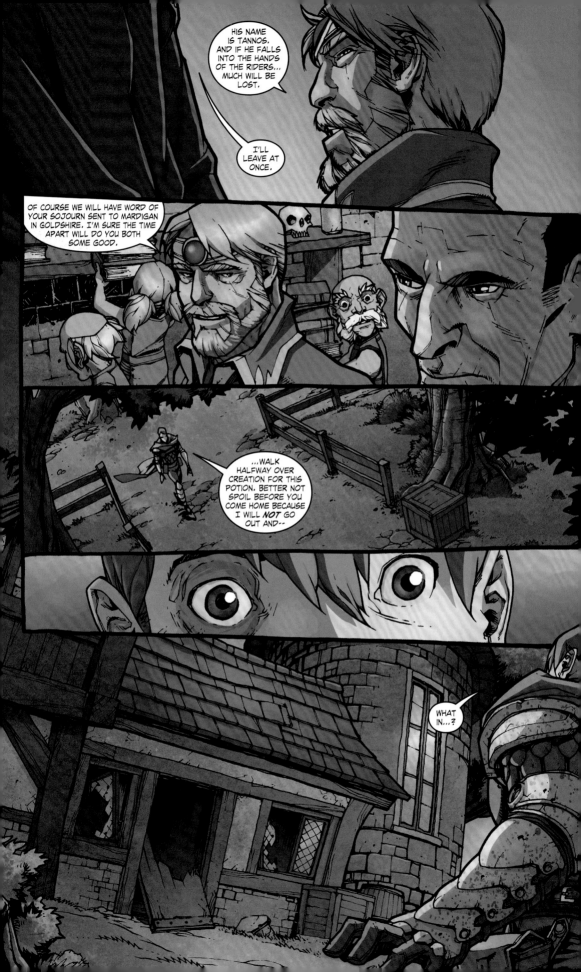

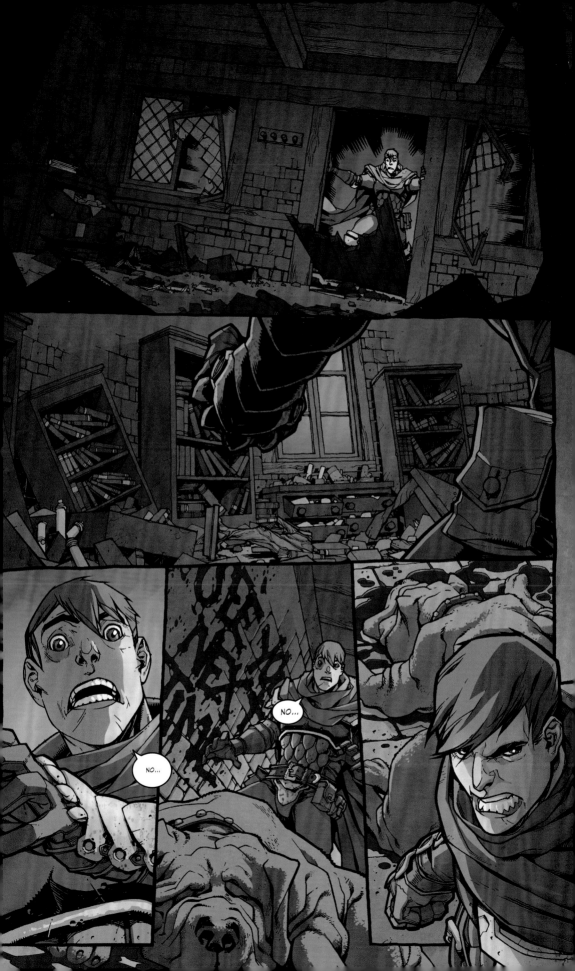

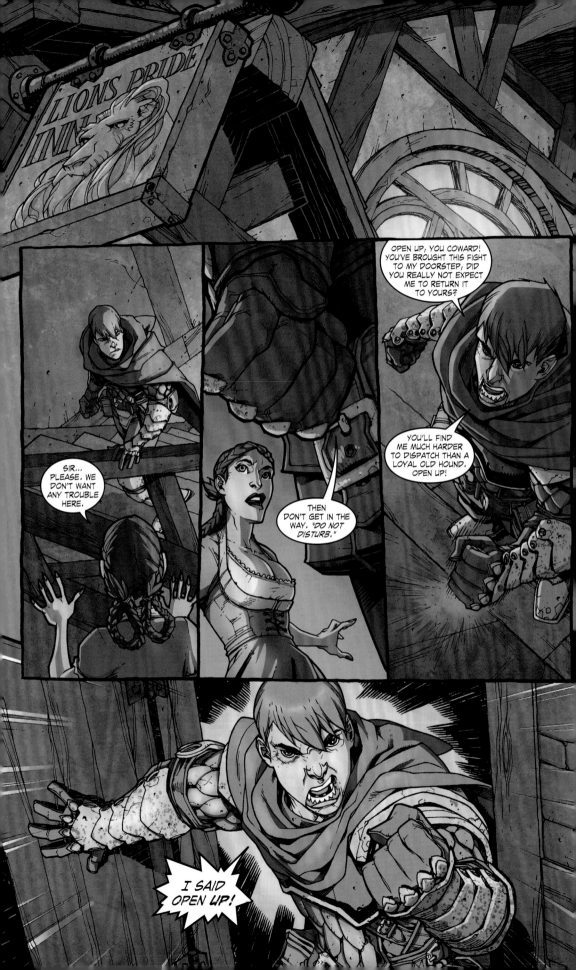

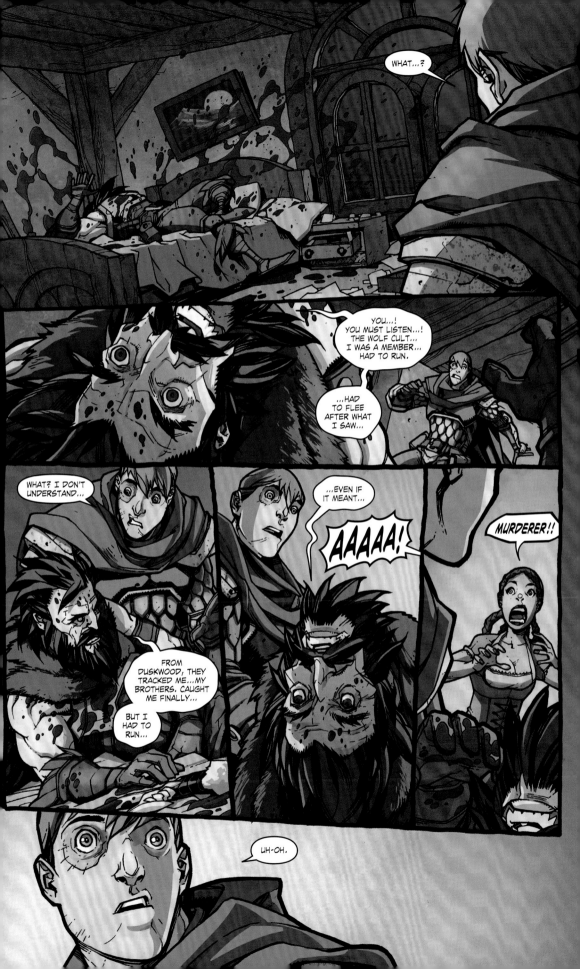

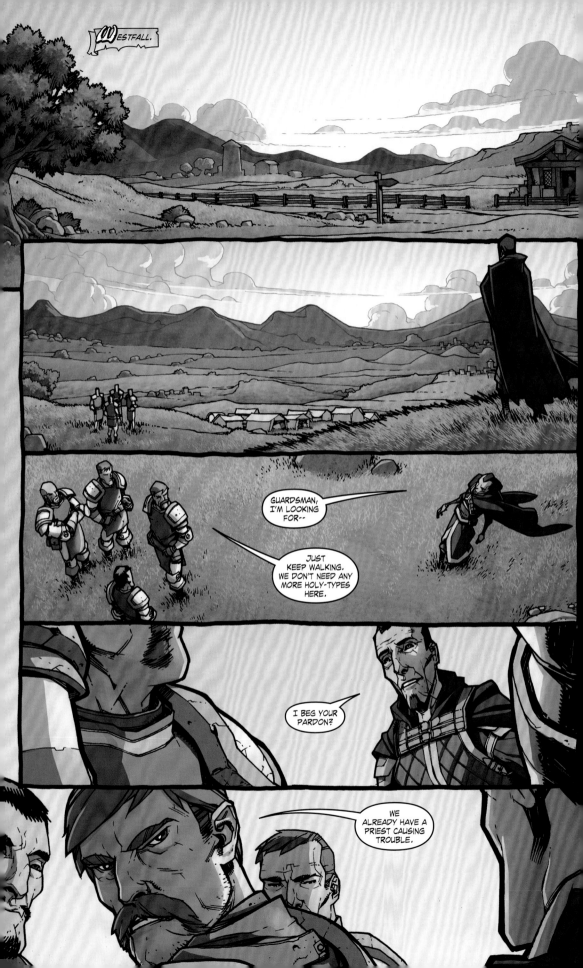

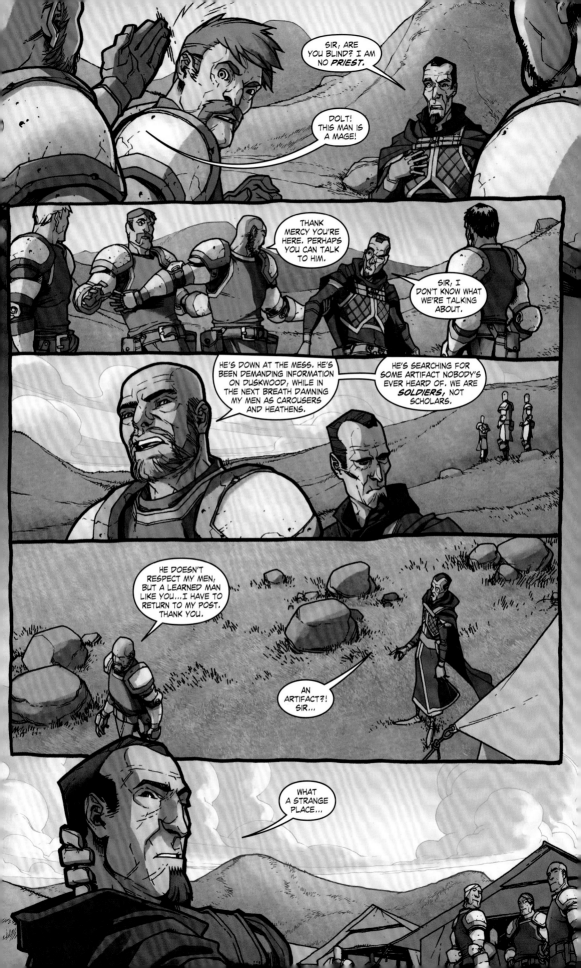

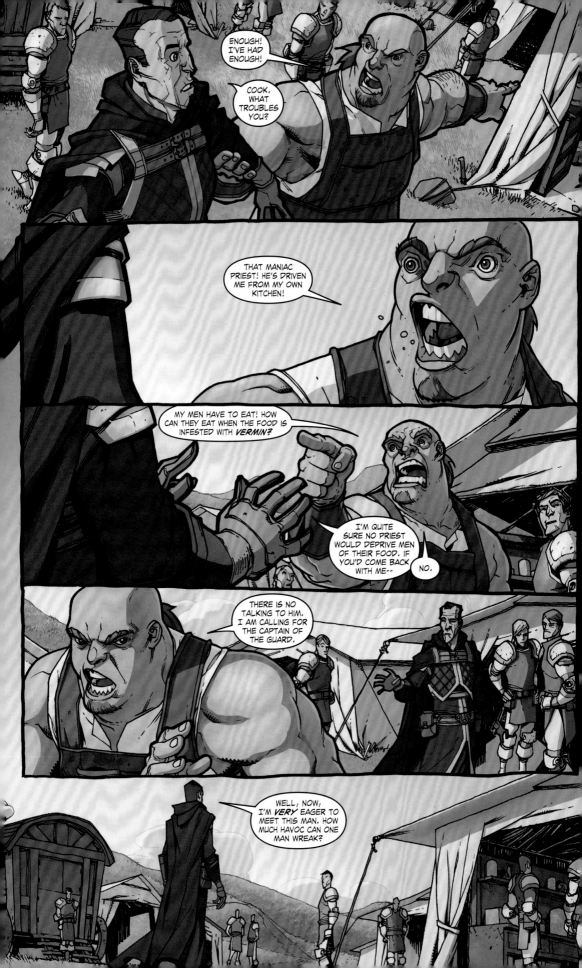

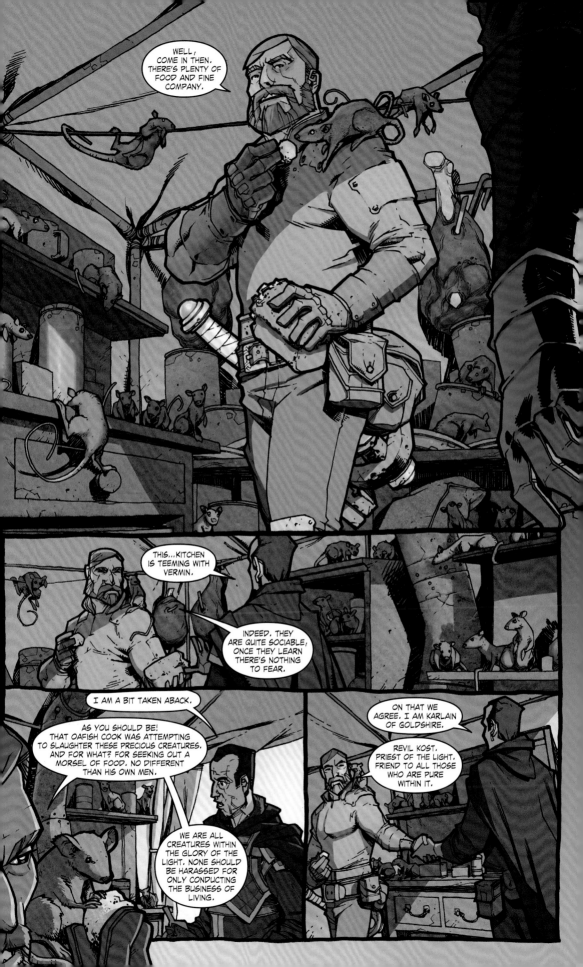

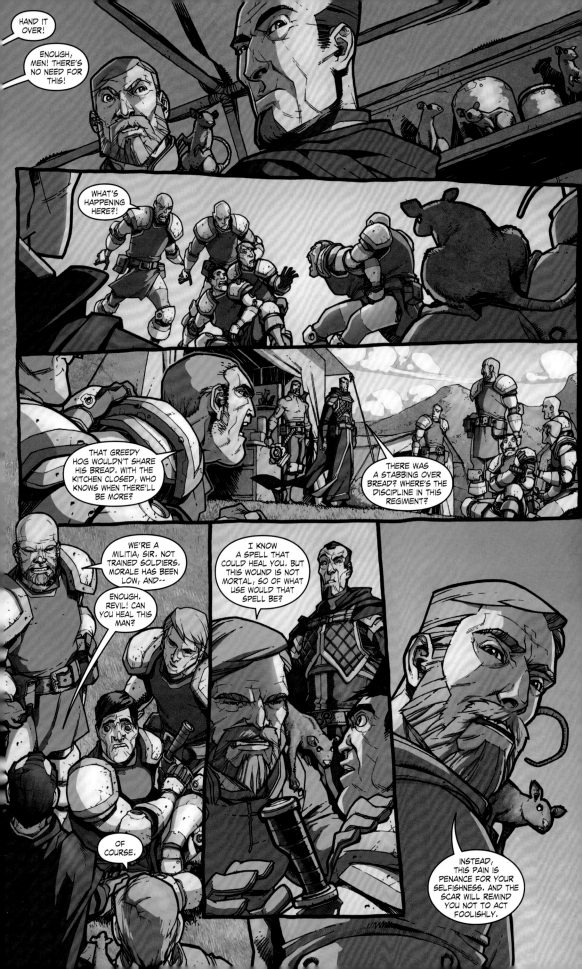

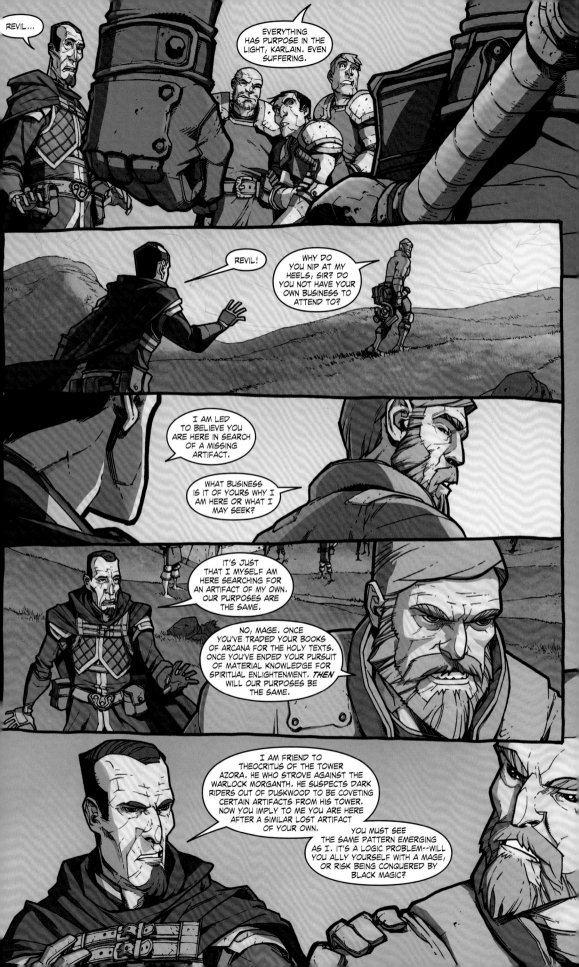

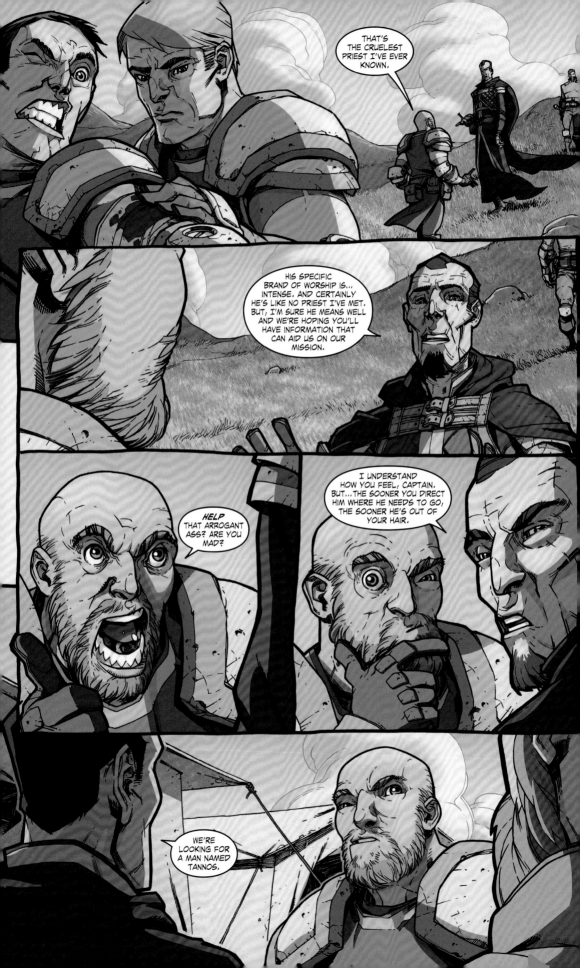

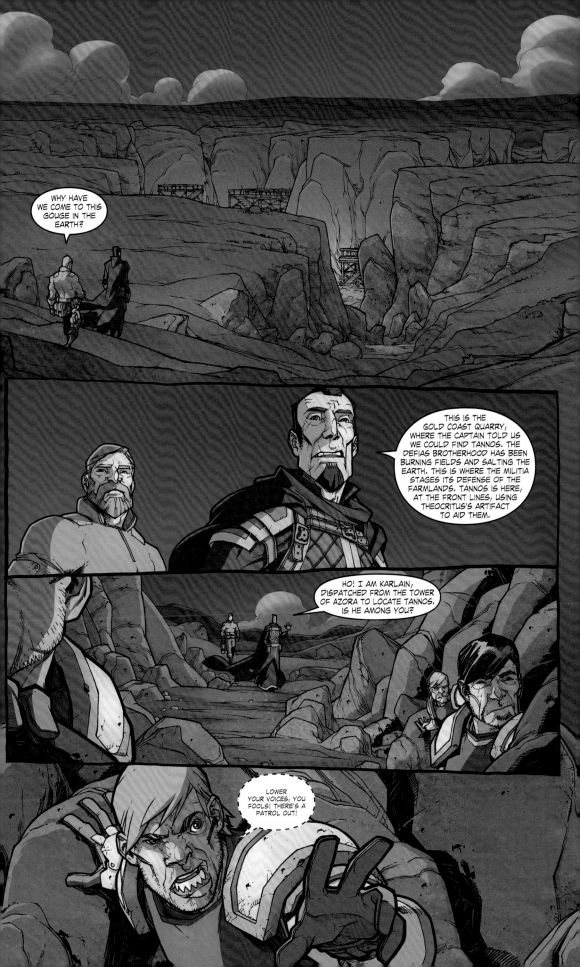

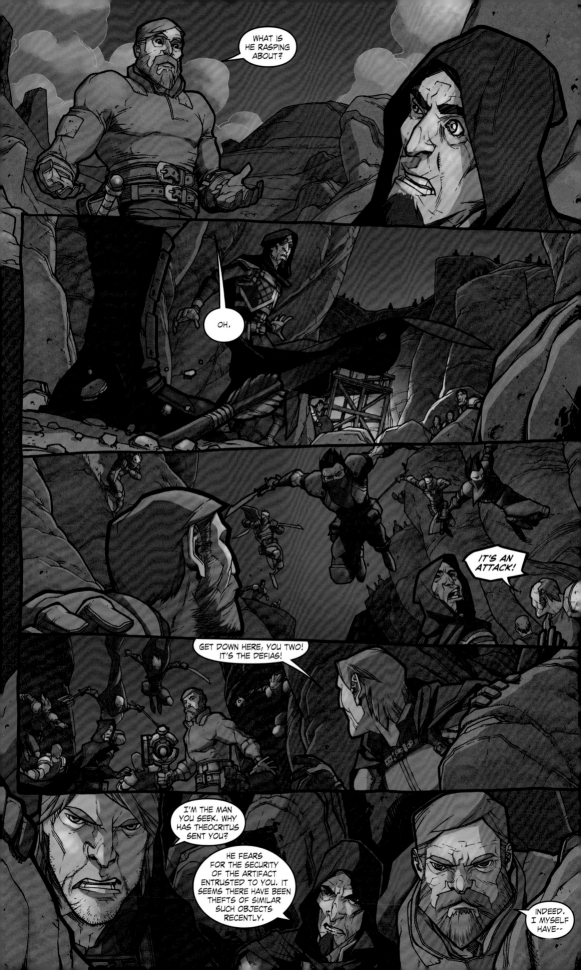

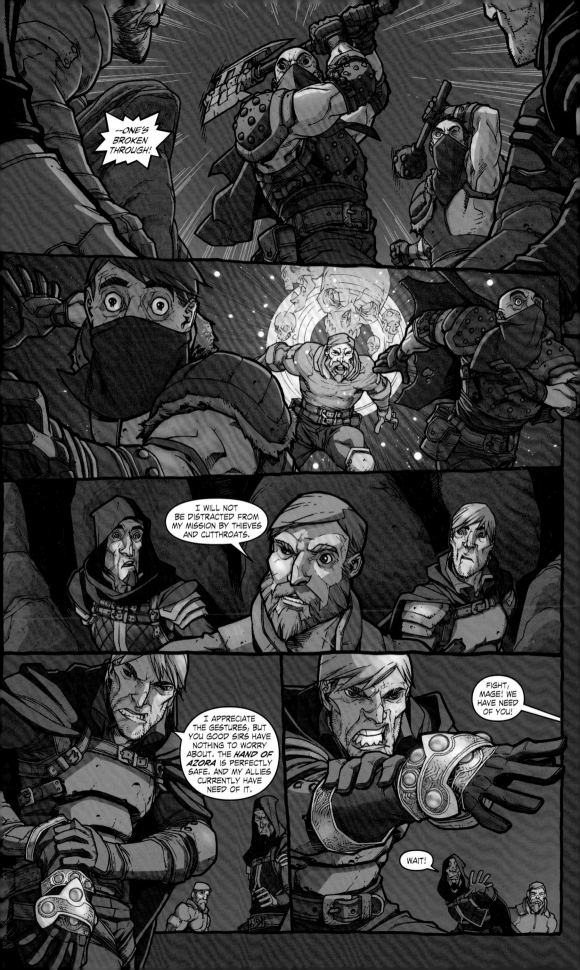

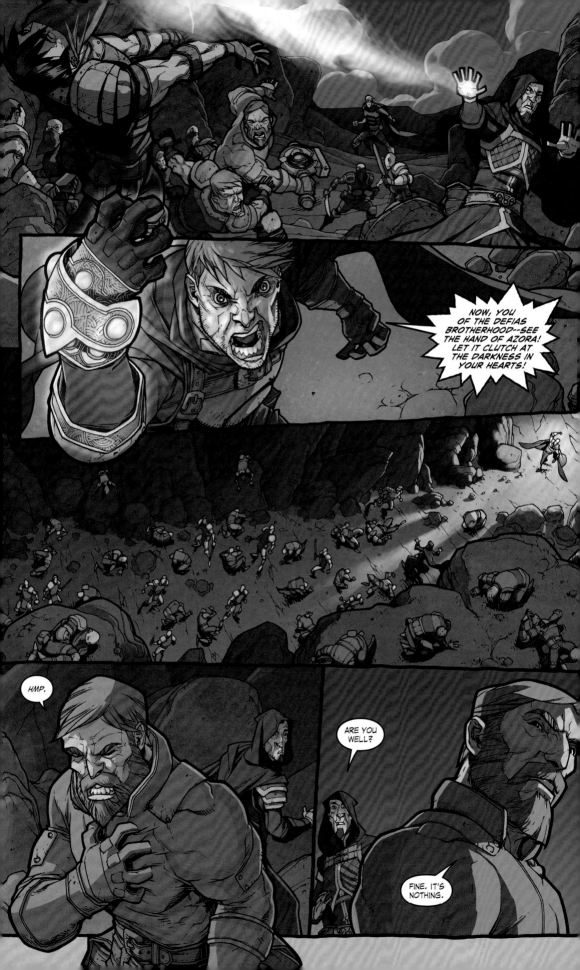

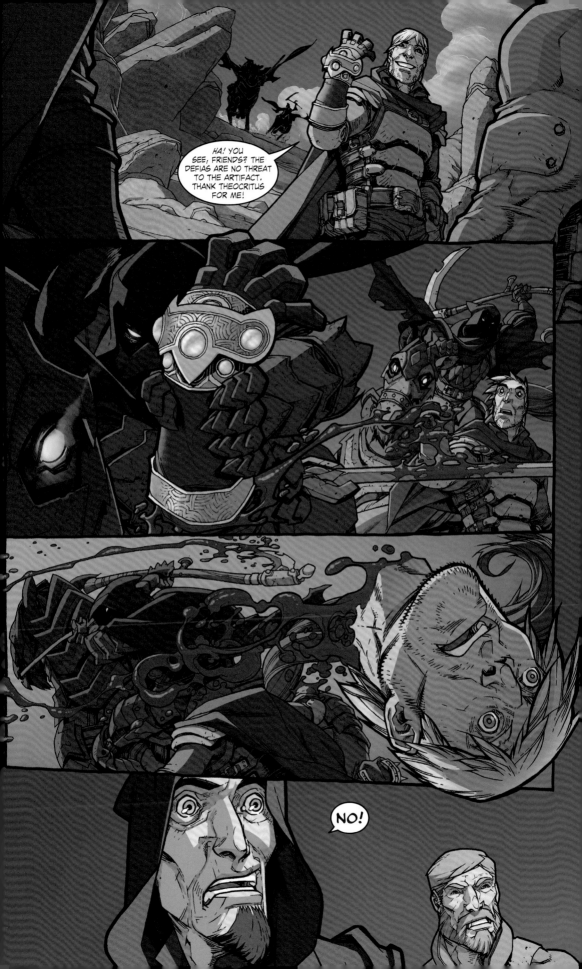

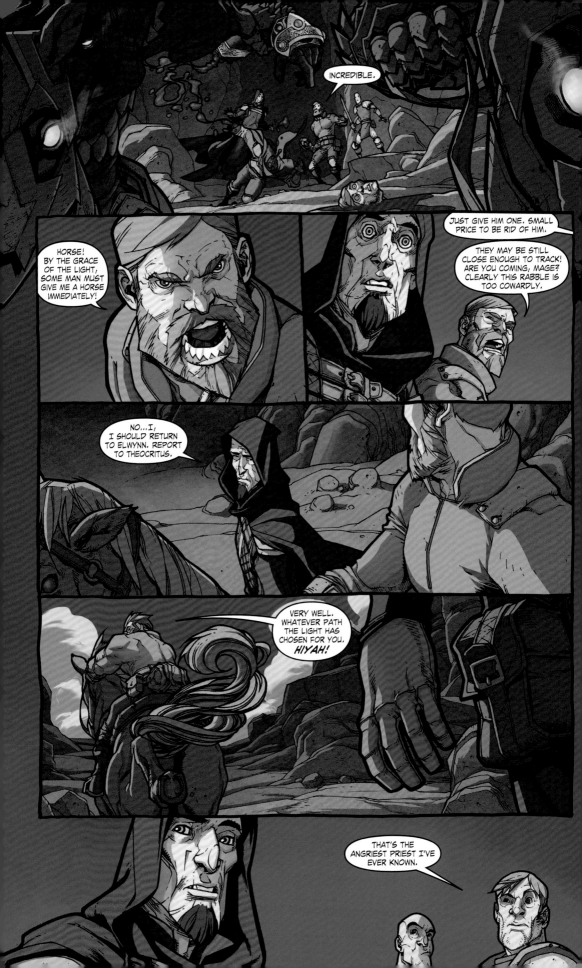

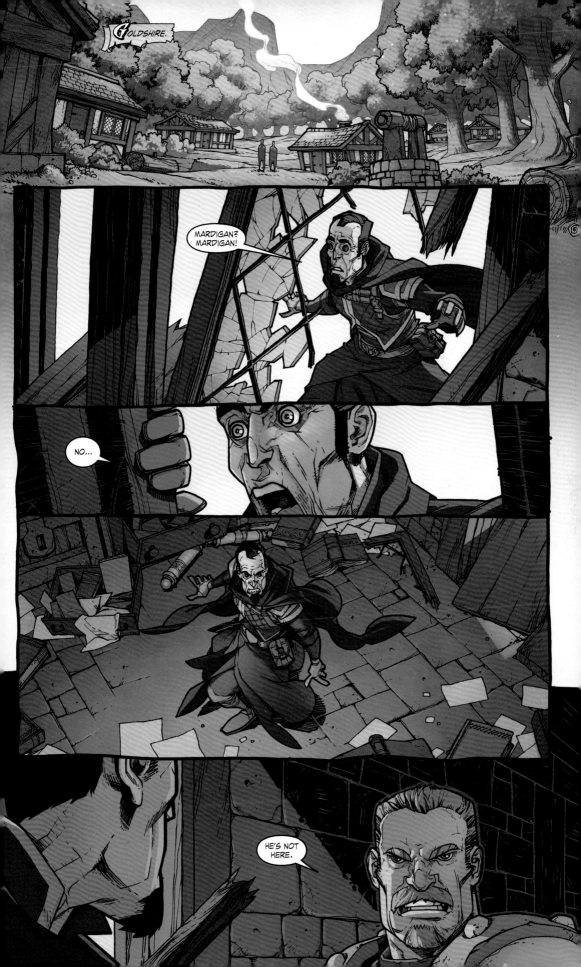

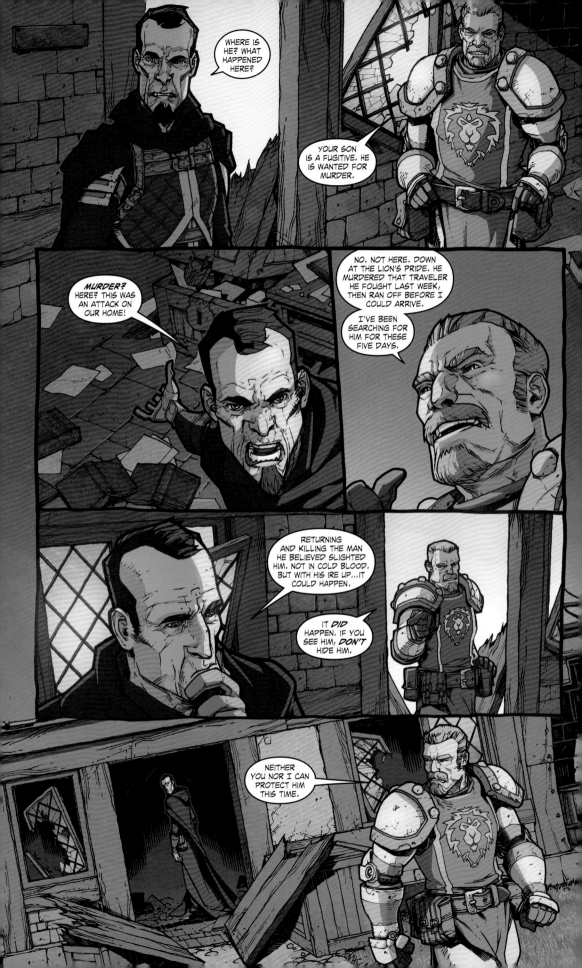

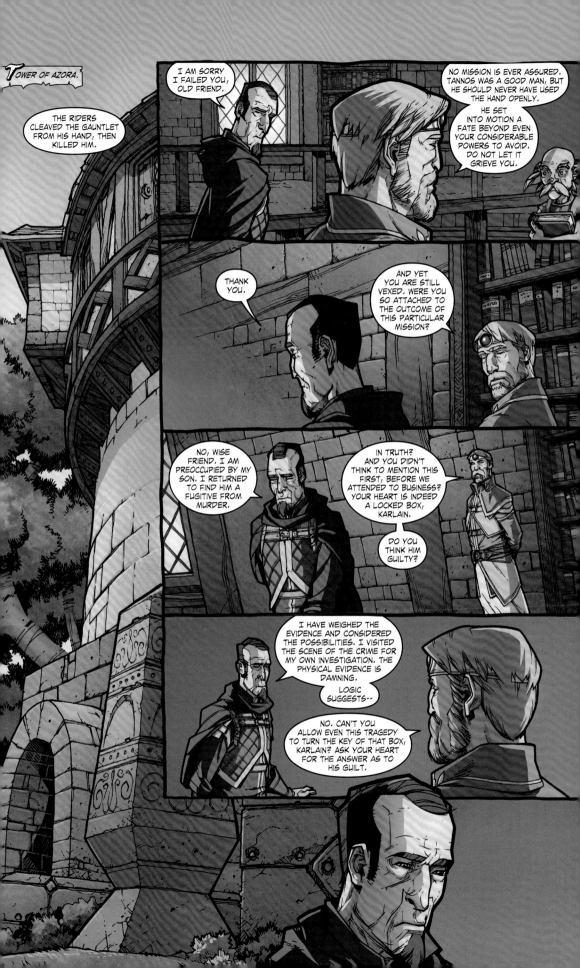

TOWER OF AZORA.

THE RIDERS CLEAVED THE GAUNTLET FROM HIS HAND, THEN KILLED HIM.

I AM SORRY I FAILED YOU, OLD FRIEND.

NO MISSION IS EVER ASSURED. TANNOS WAS A GOOD MAN, BUT HE SHOULD NEVER HAVE USED THE HAND OPENLY.

HE SET INTO MOTION A FATE BEYOND EVEN YOUR CONSIDERABLE POWERS TO AVOID. DO NOT LET IT GRIEVE YOU.

THANK YOU.

AND YET YOU ARE STILL VEXED. WERE YOU SO ATTACHED TO THE OUTCOME OF THIS PARTICULAR MISSION?

NO, WISE FRIEND. I AM PREOCCUPIED BY MY SON. I RETURNED TO FIND HIM A FUGITIVE FROM MURDER.

IN TRUTH? AND YOU DIDN'T THINK TO MENTION THIS FIRST, BEFORE WE ATTENDED TO BUSINESS? YOUR HEART IS INDEED A LOCKED BOX, KARLAIN.

DO YOU THINK HIM GUILTY?

I HAVE WEIGHED THE EVIDENCE AND CONSIDERED THE POSSIBILITIES. I VISITED THE SCENE OF THE CRIME FOR MY OWN INVESTIGATION. THE PHYSICAL EVIDENCE IS DAMNING.

LOGIC SUGGESTS--

NO. CAN'T YOU ALLOW EVEN THIS TRAGEDY TO TURN THE KEY OF THAT BOX, KARLAIN? ASK YOUR HEART FOR THE ANSWER AS TO HIS GUILT.

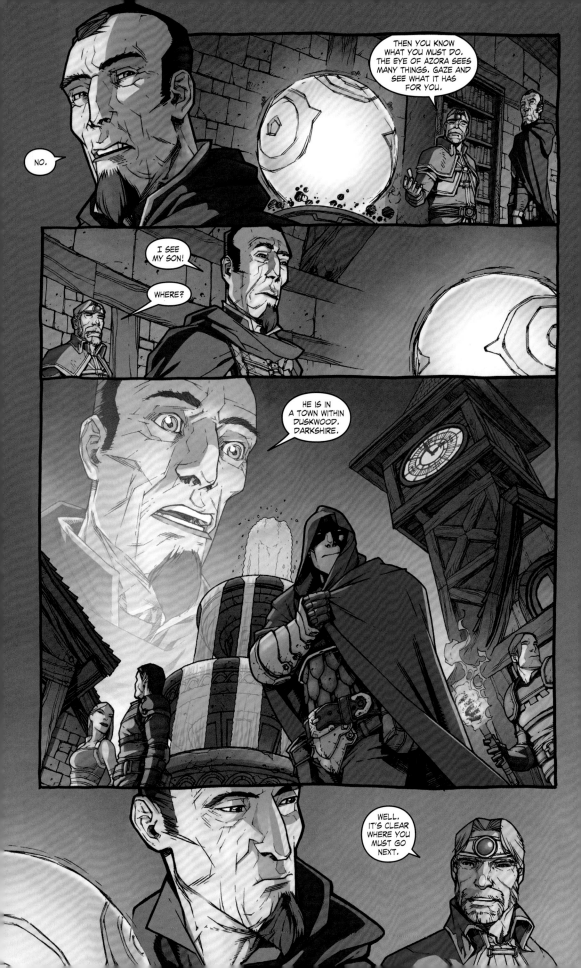

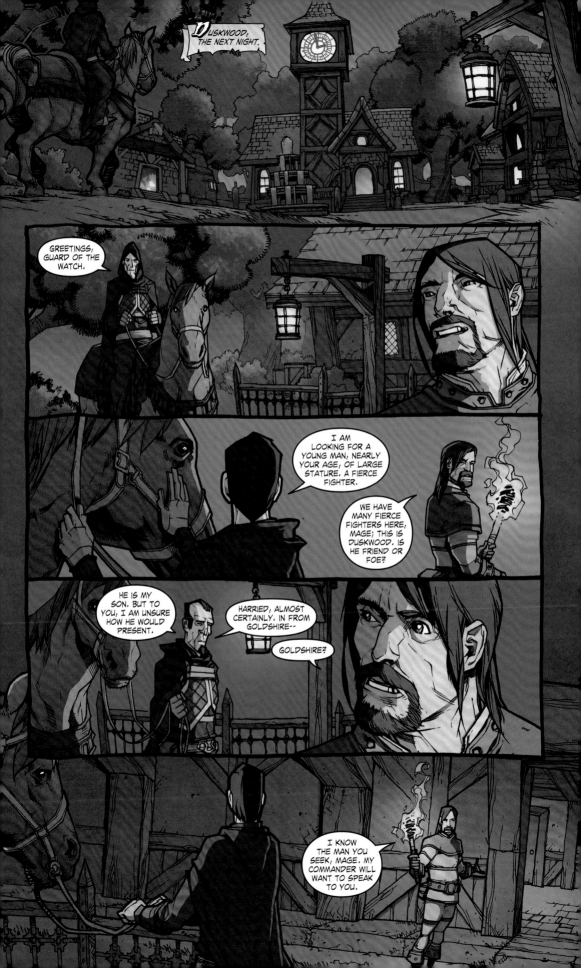

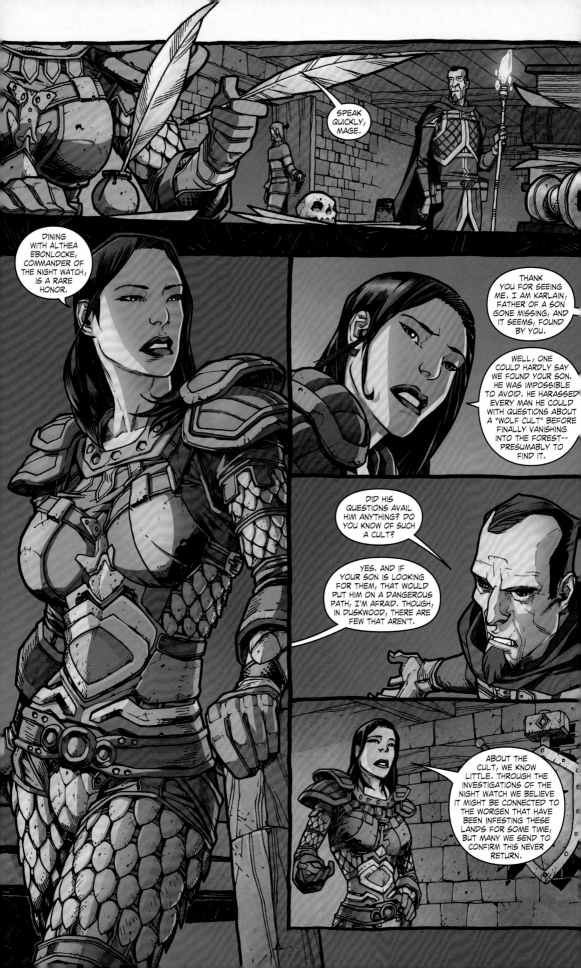

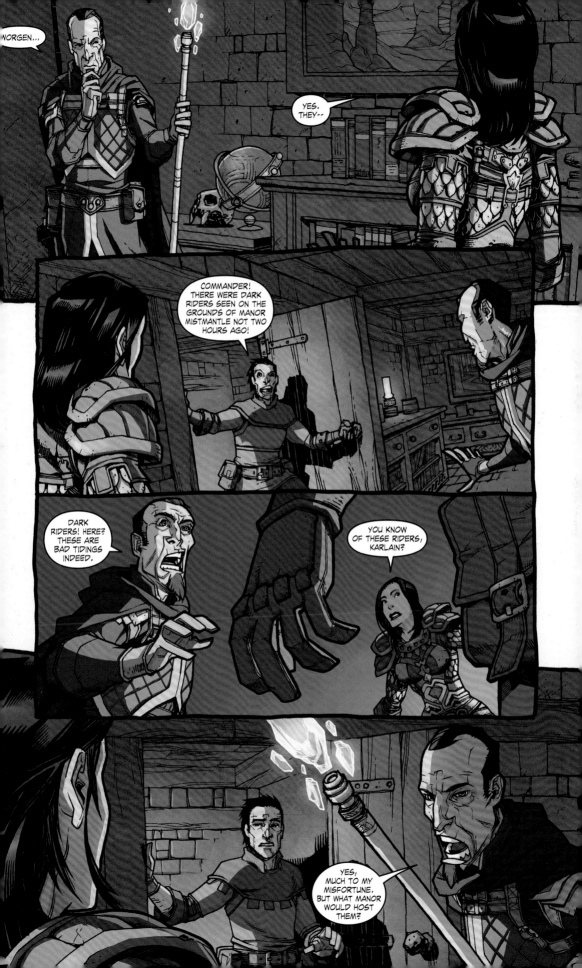

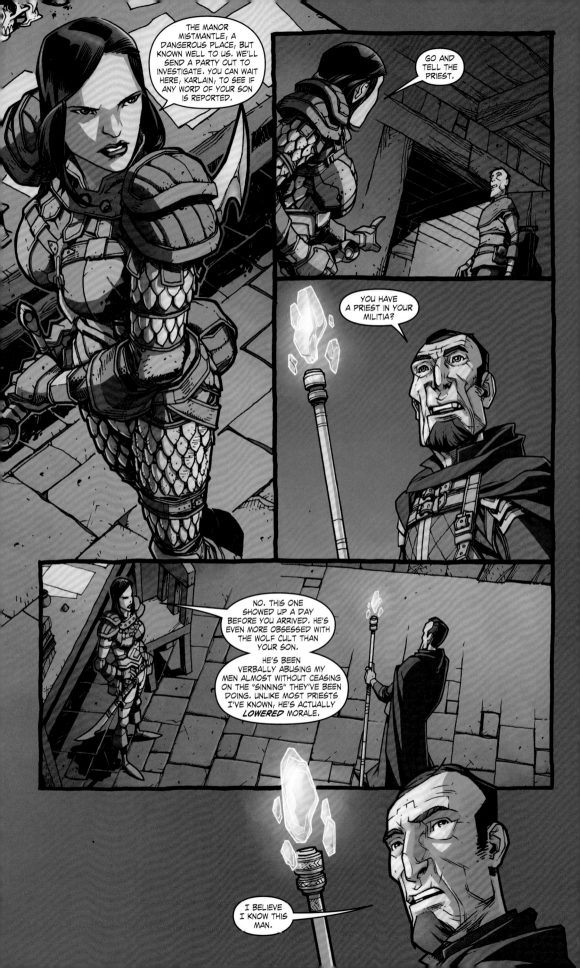

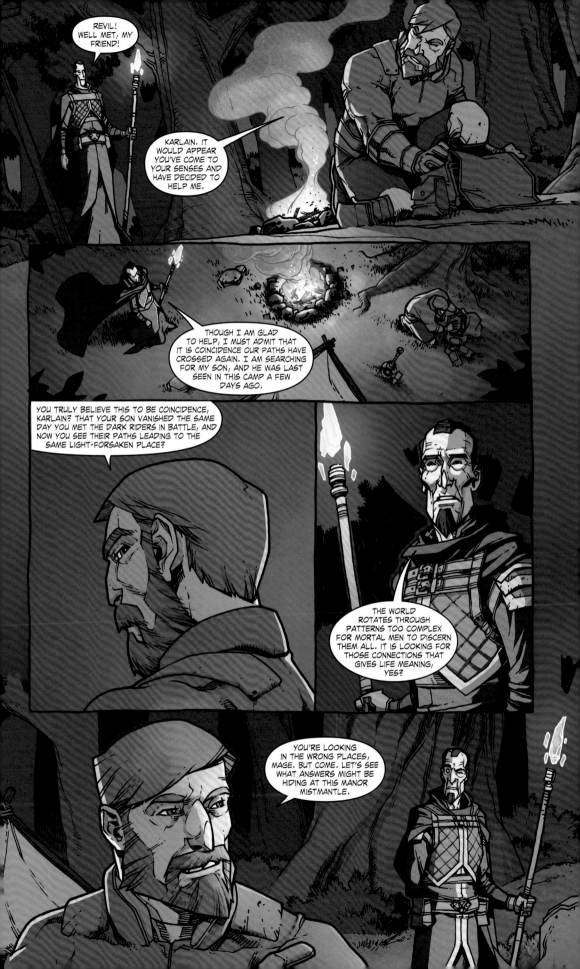

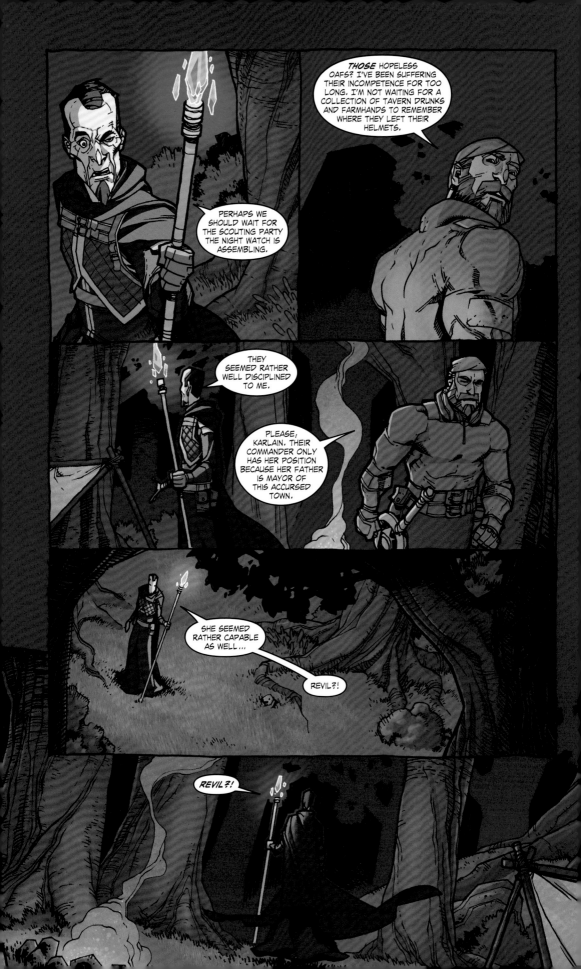

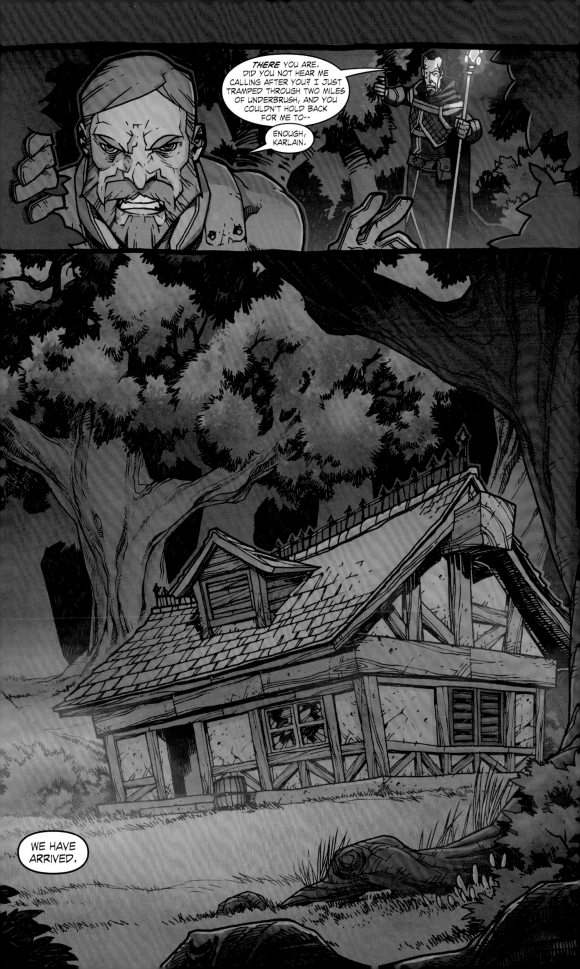

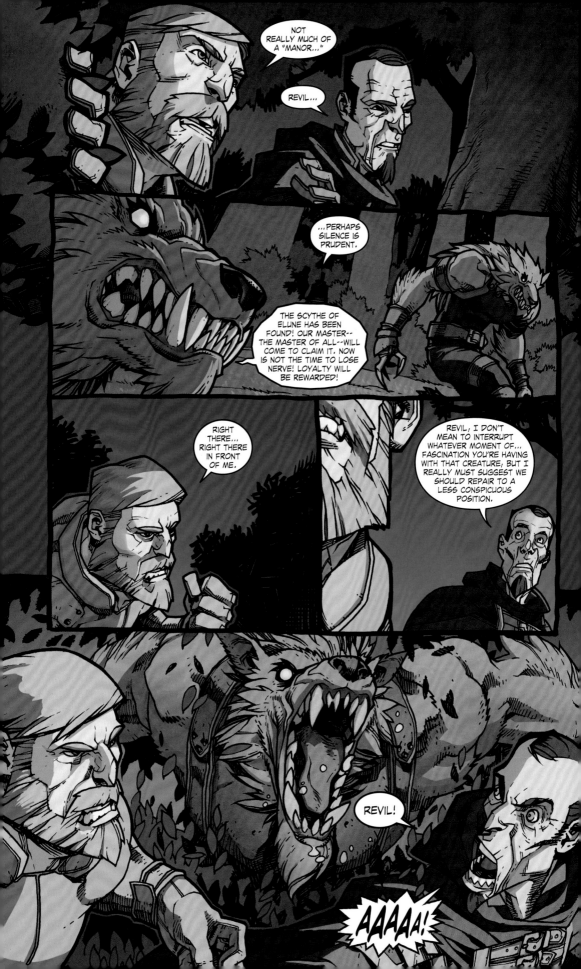

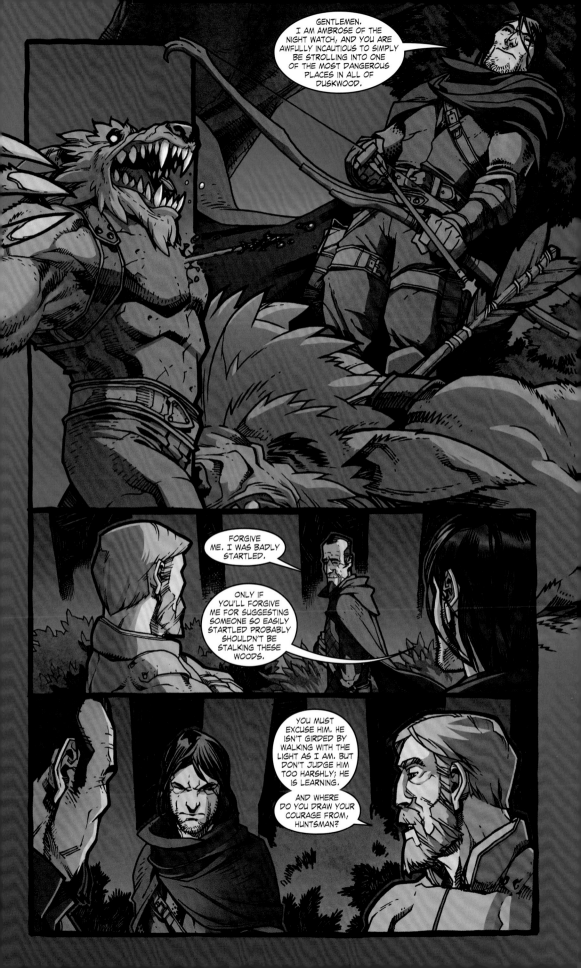

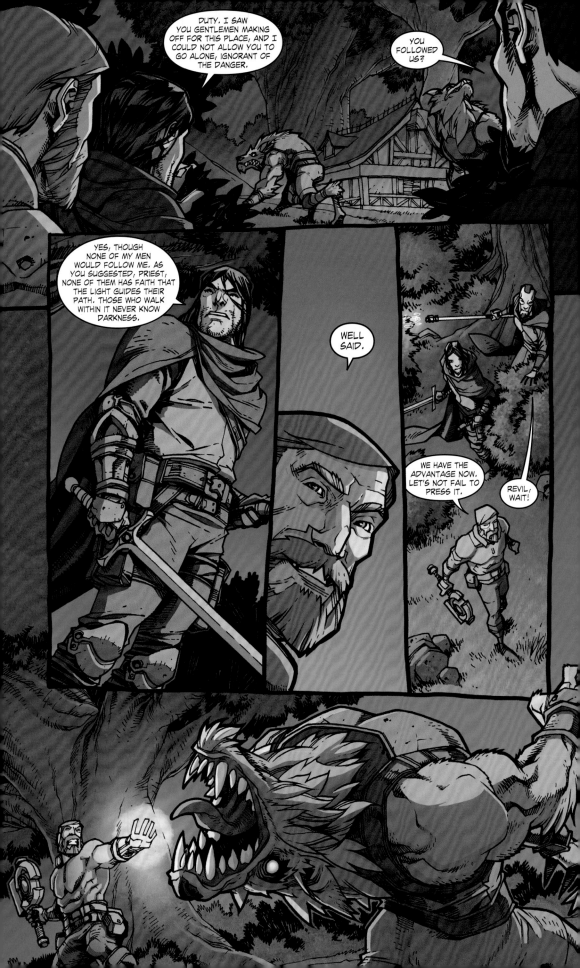

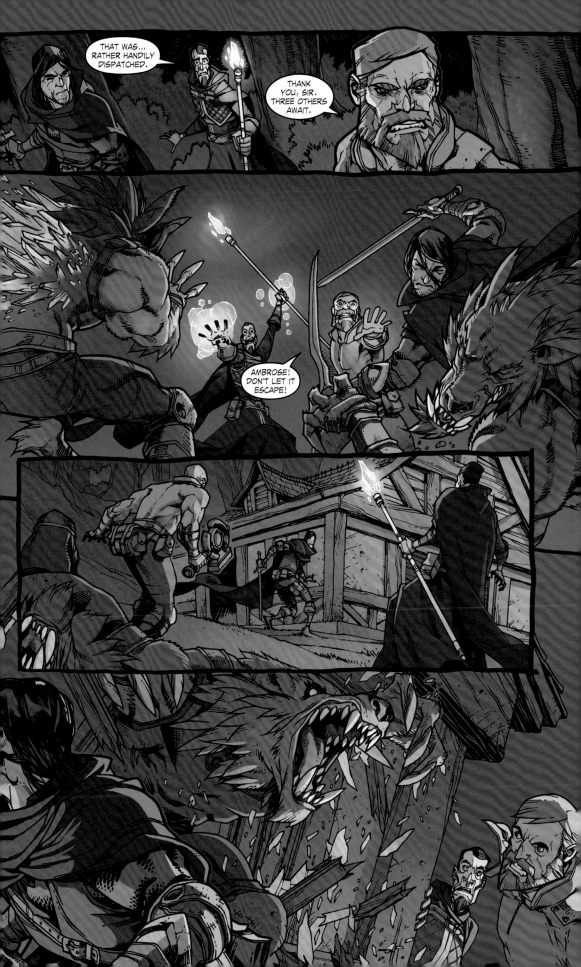

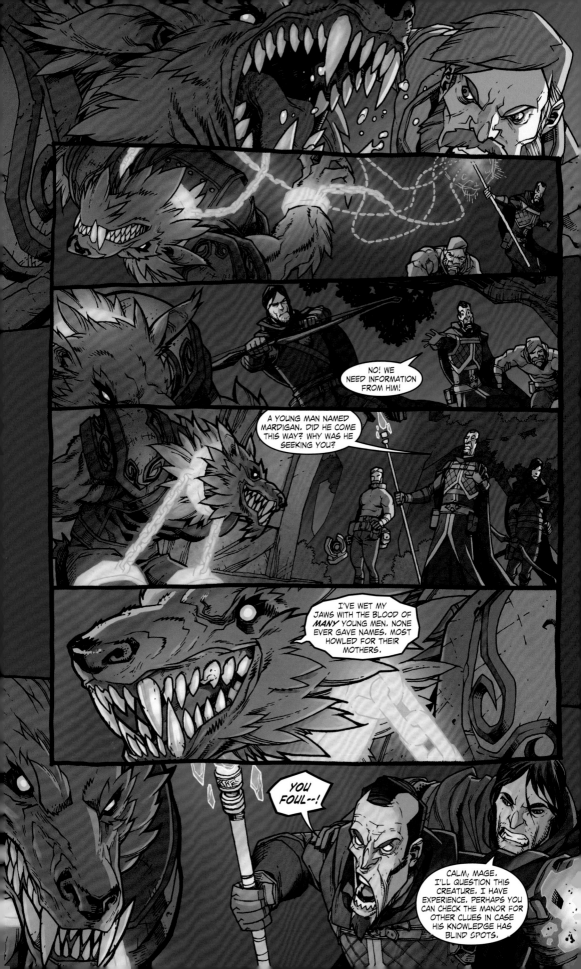

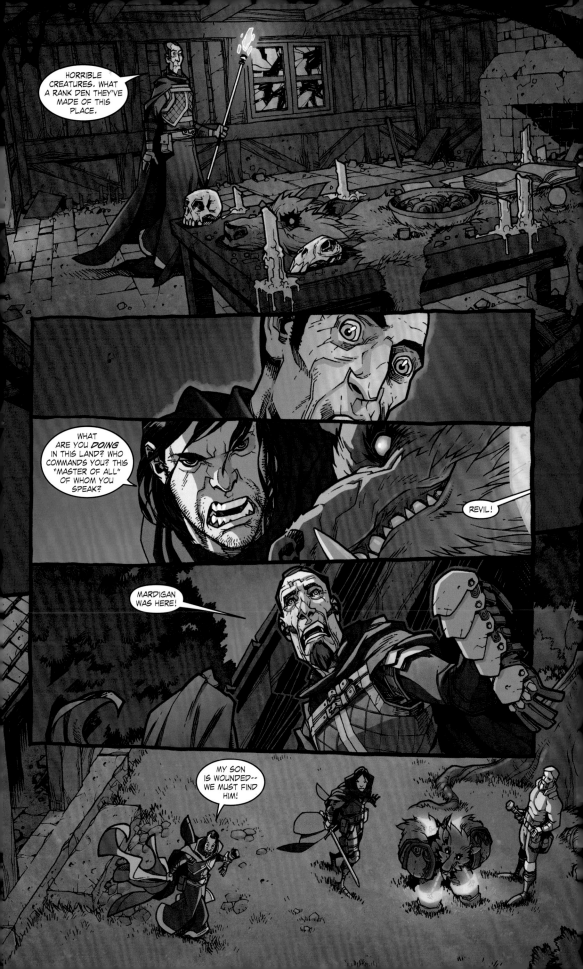

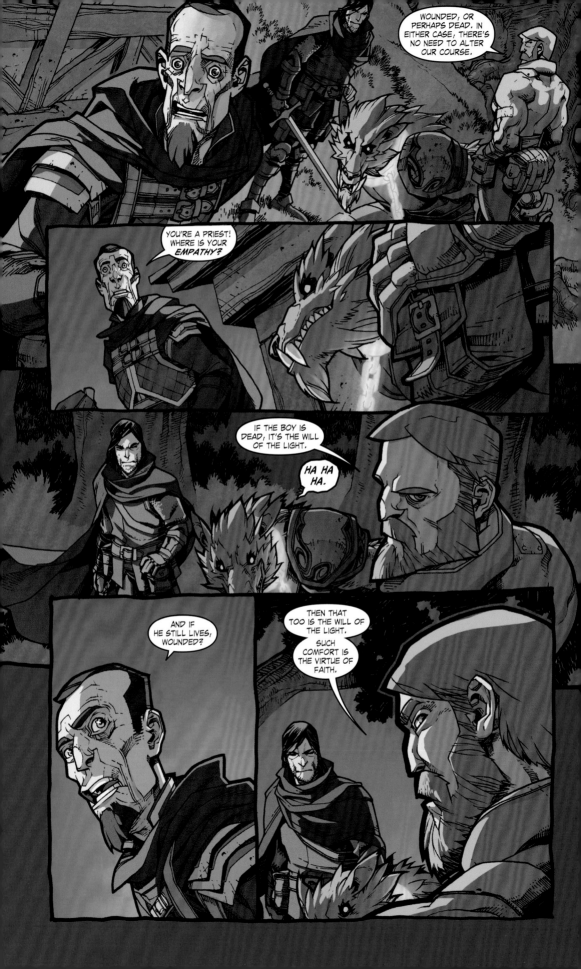

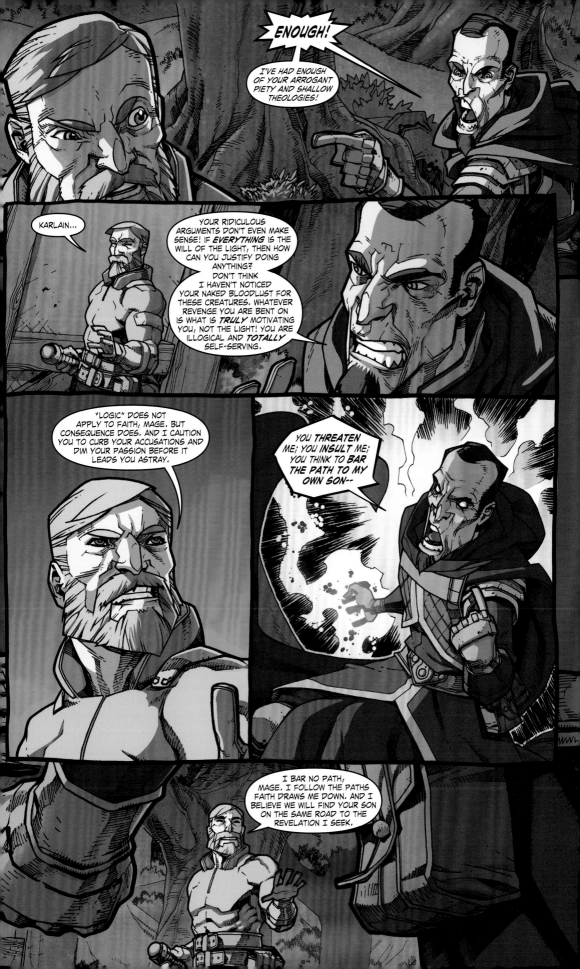

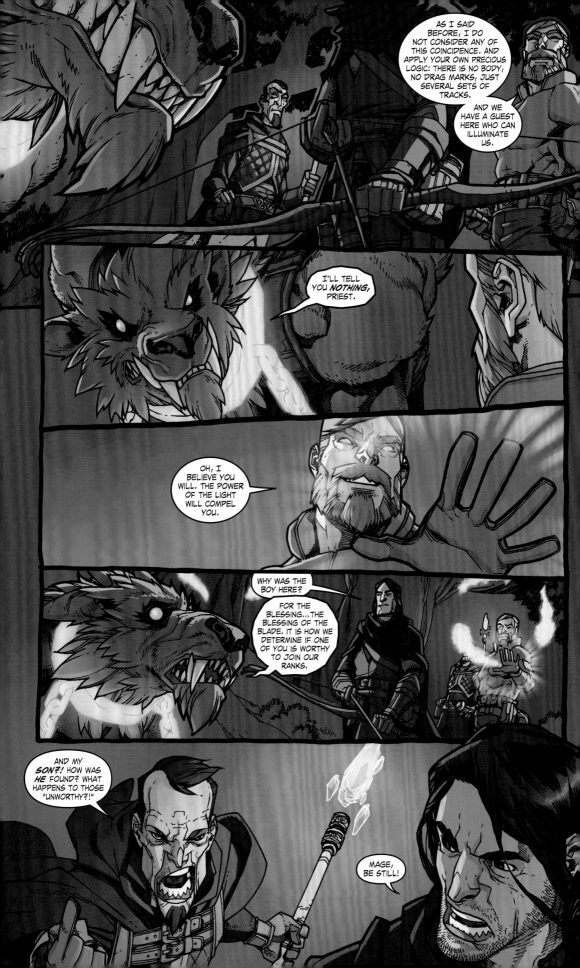

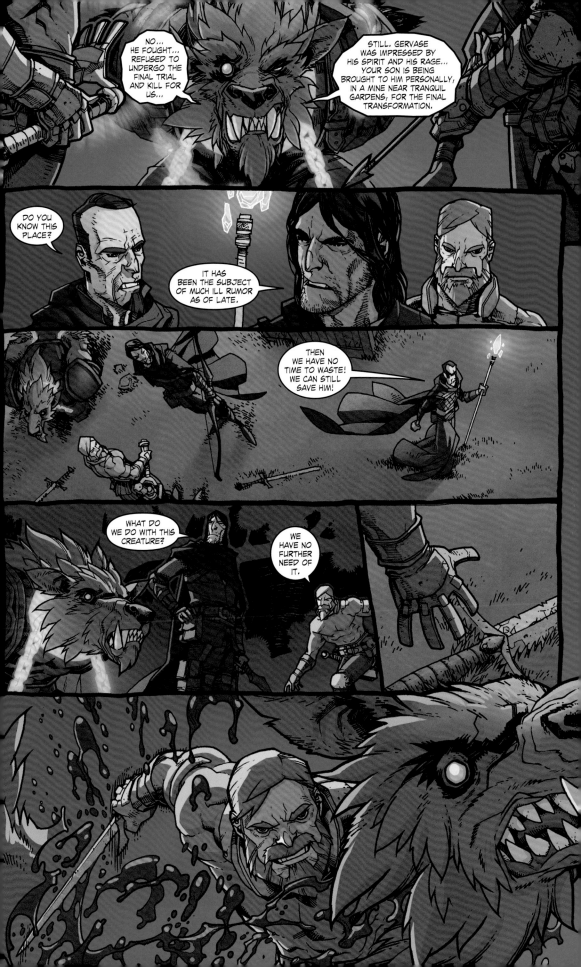

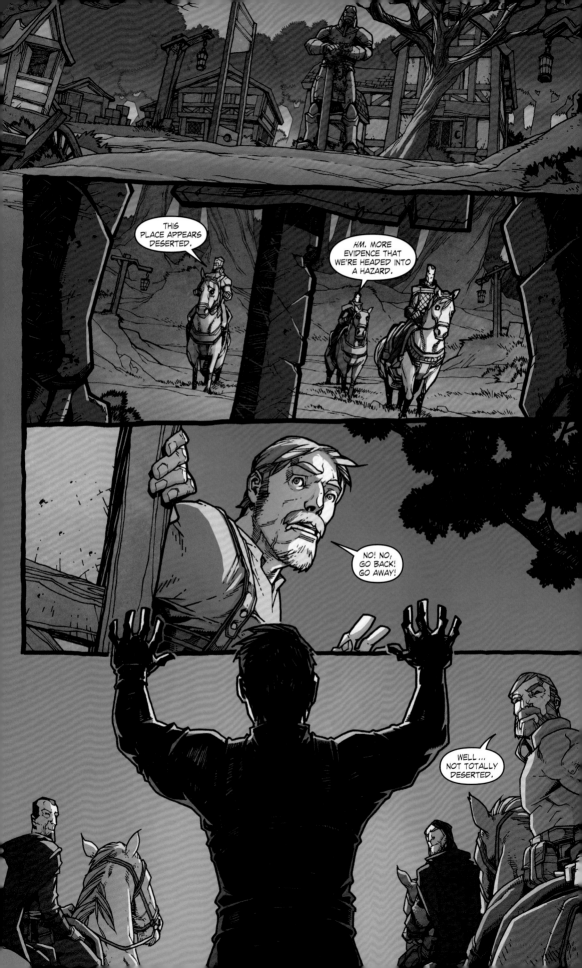

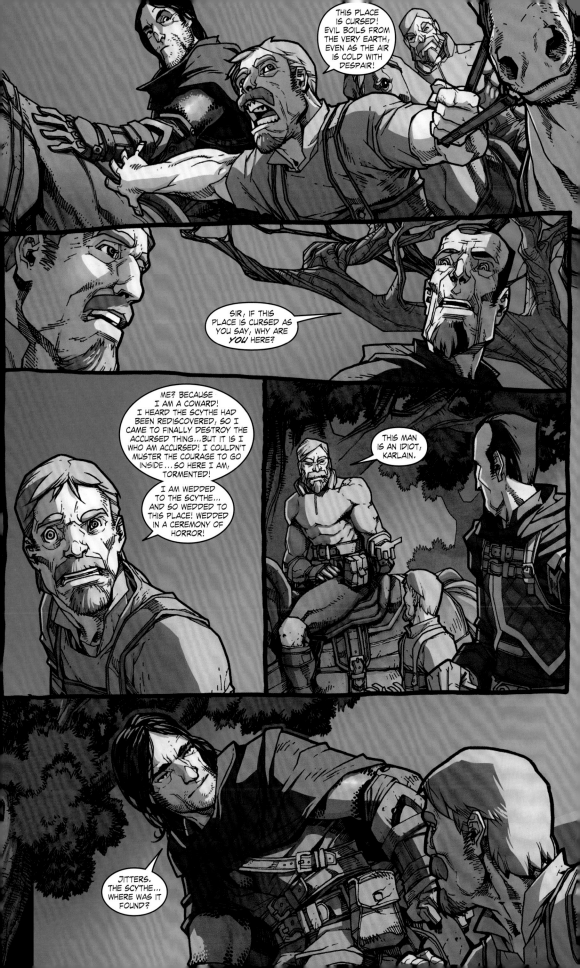

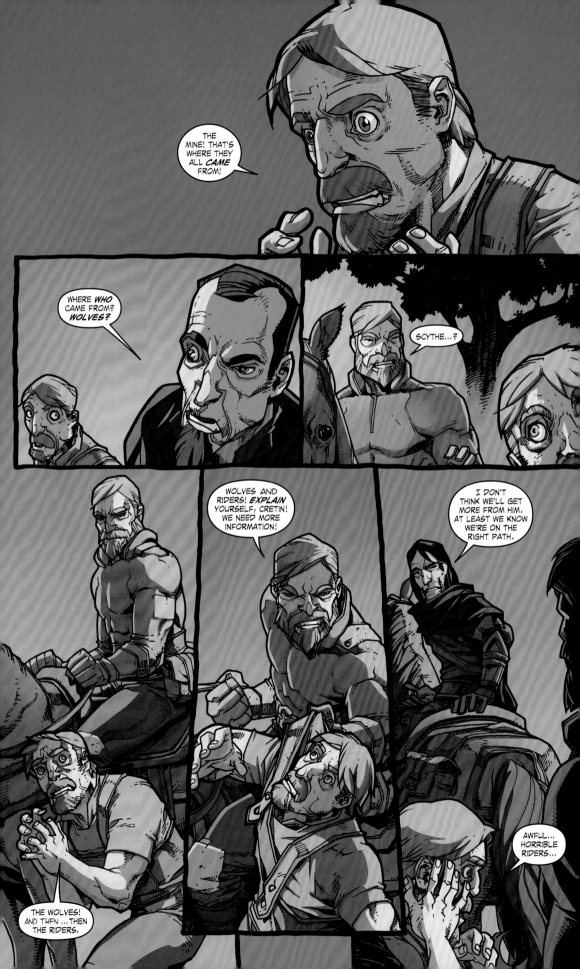

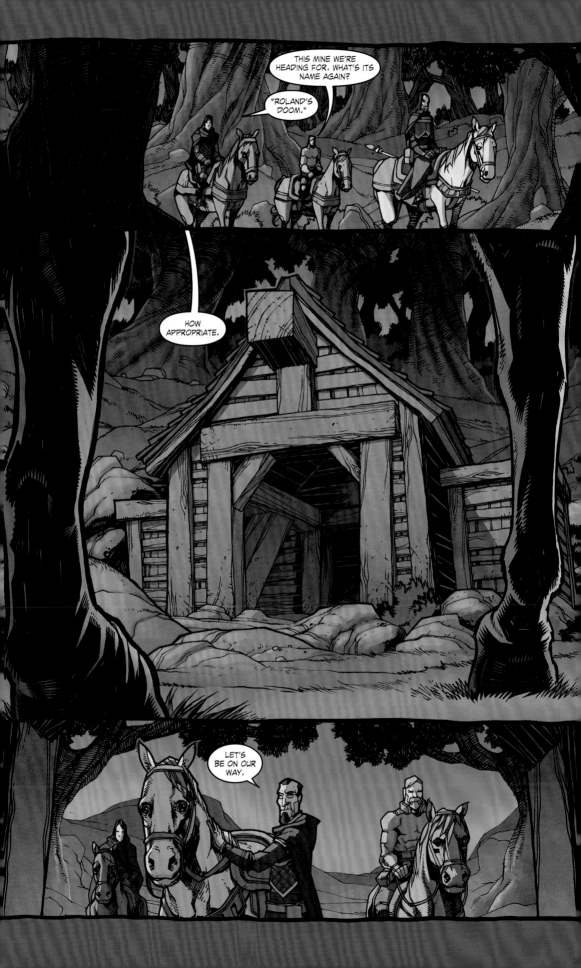

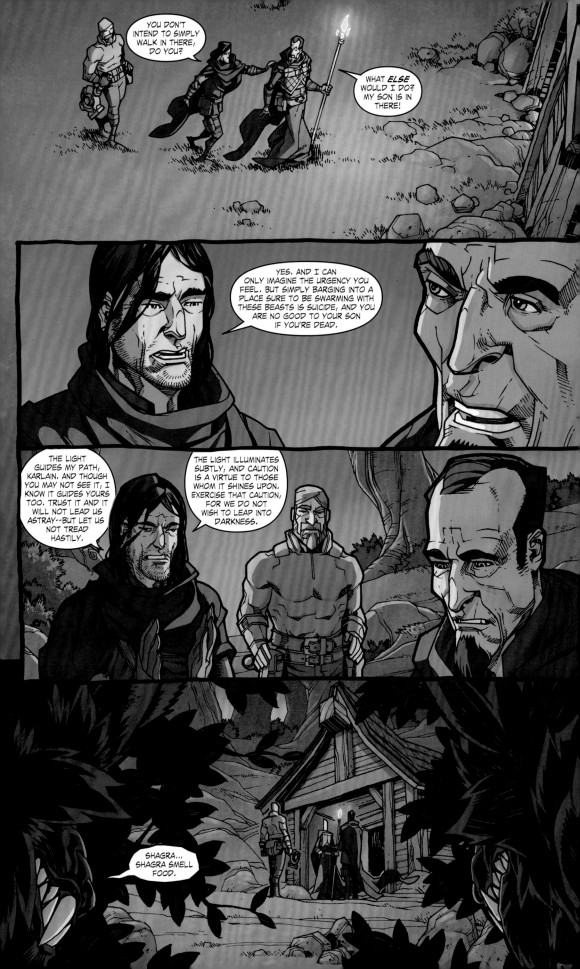

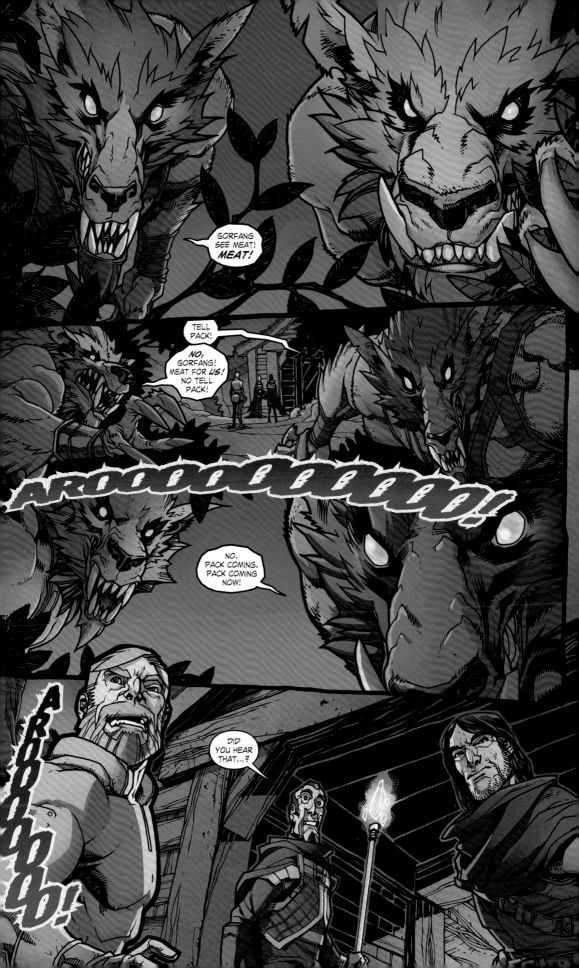

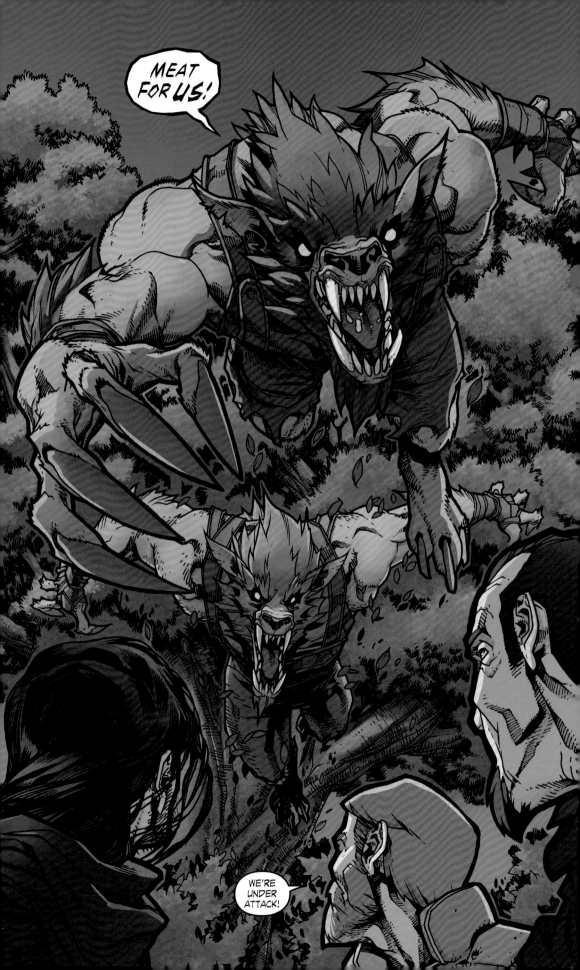

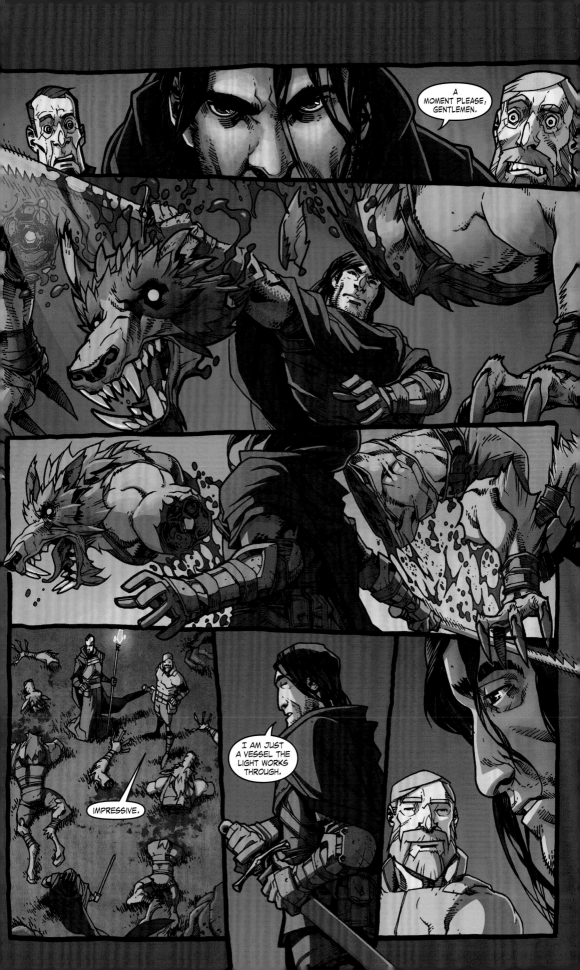

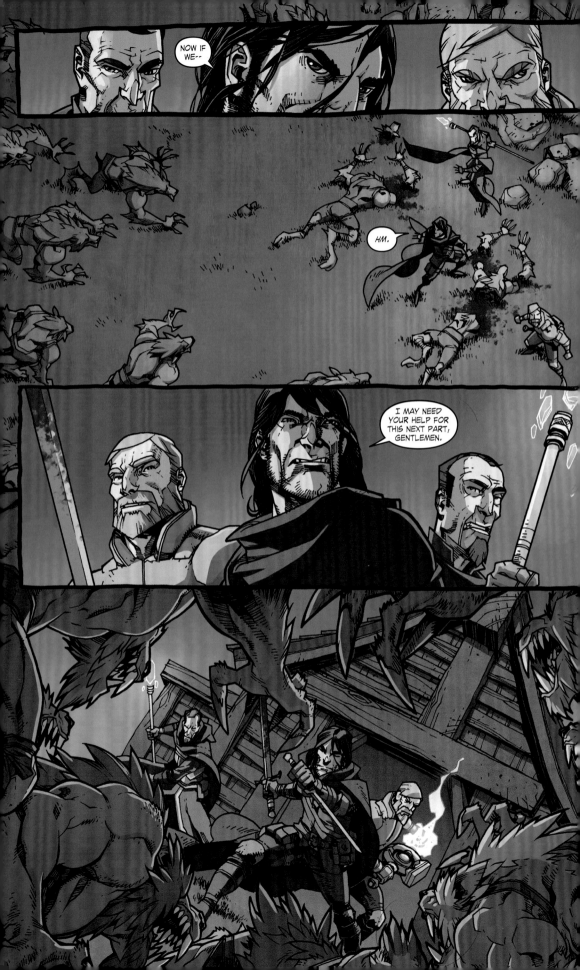

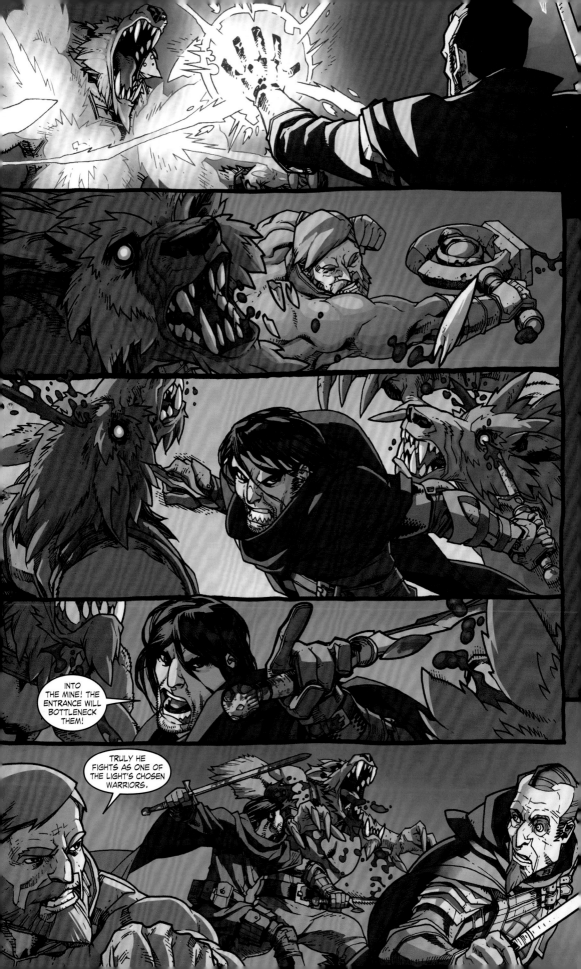

INTO THE MINE! THE ENTRANCE WILL BOTTLENECK THEM!

TRULY HE FIGHTS AS ONE OF THE LIGHT'S CHOSEN WARRIORS.

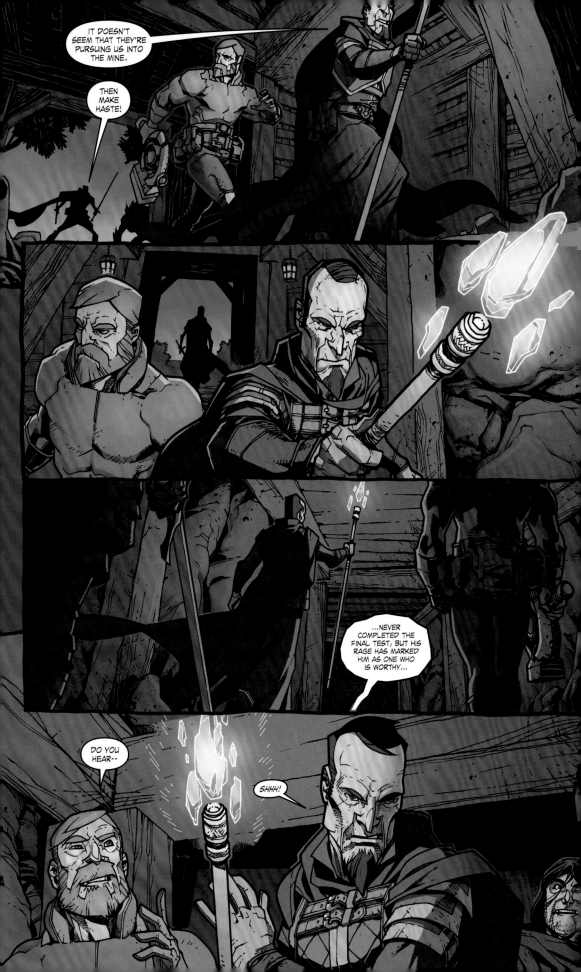

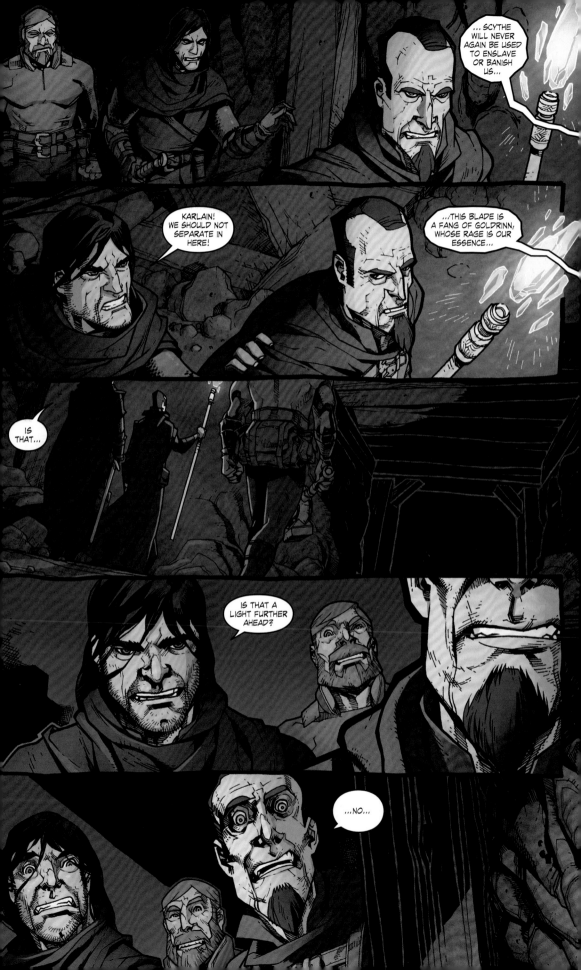

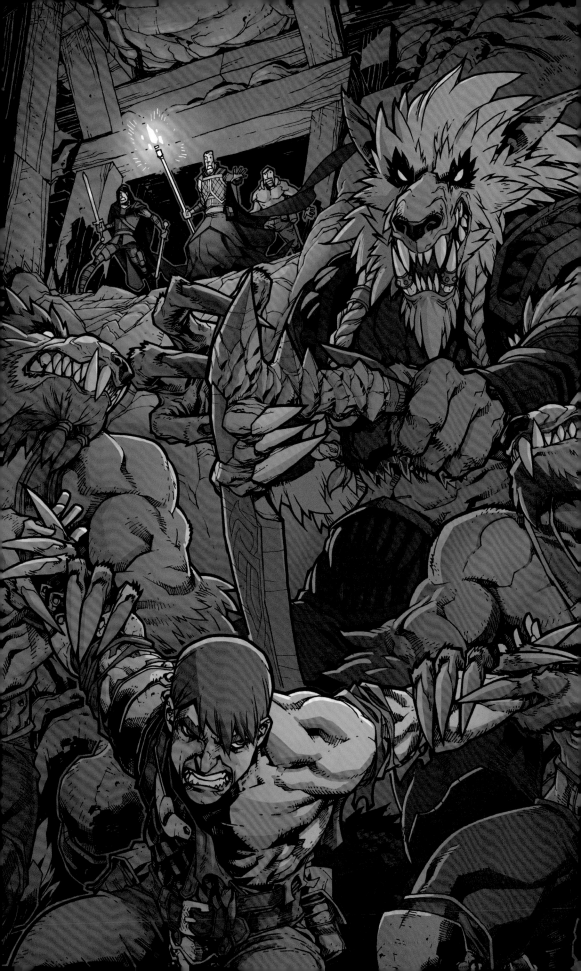

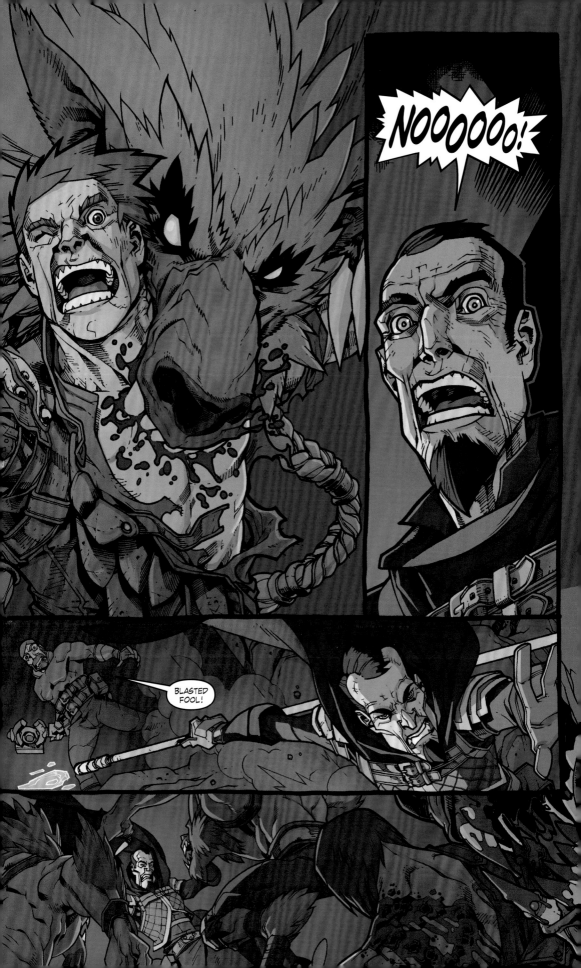

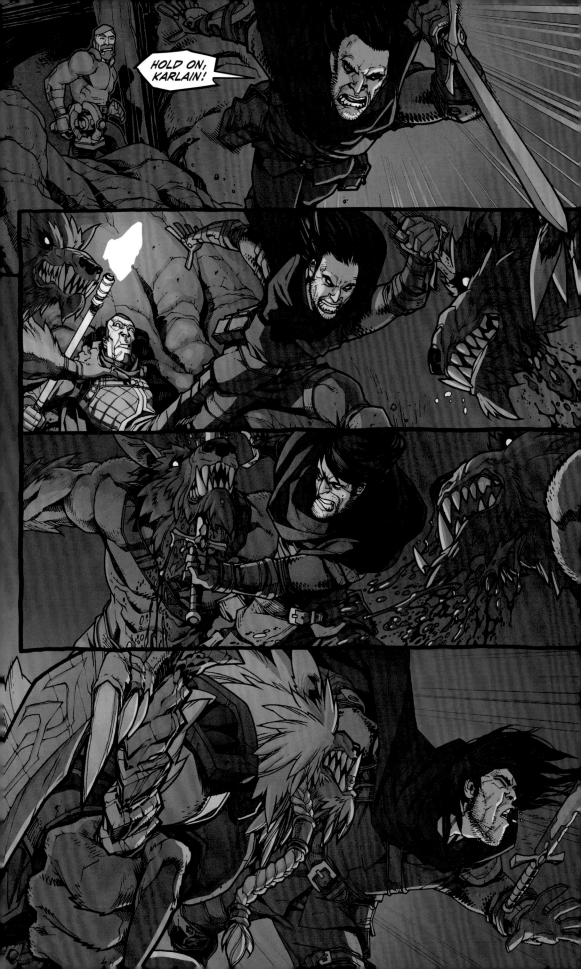

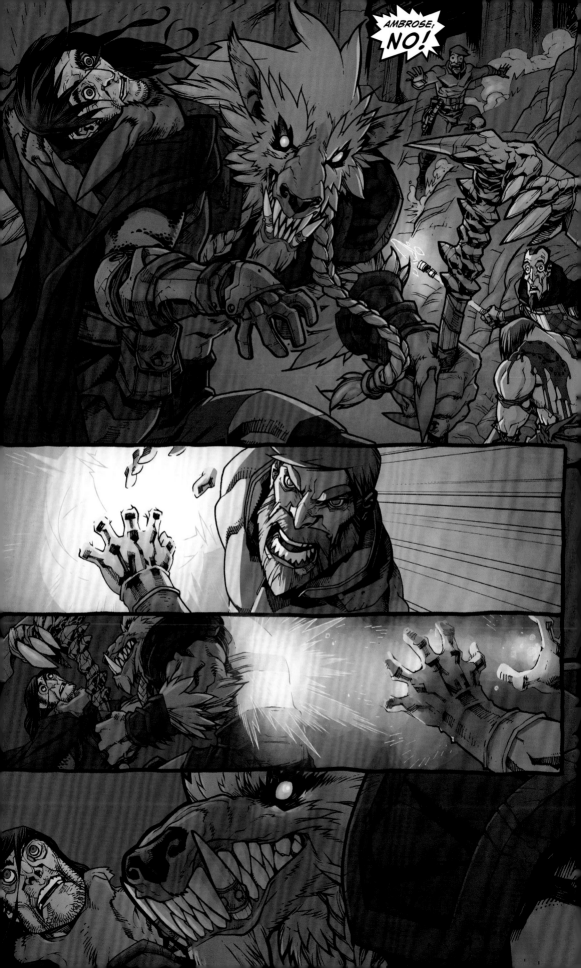

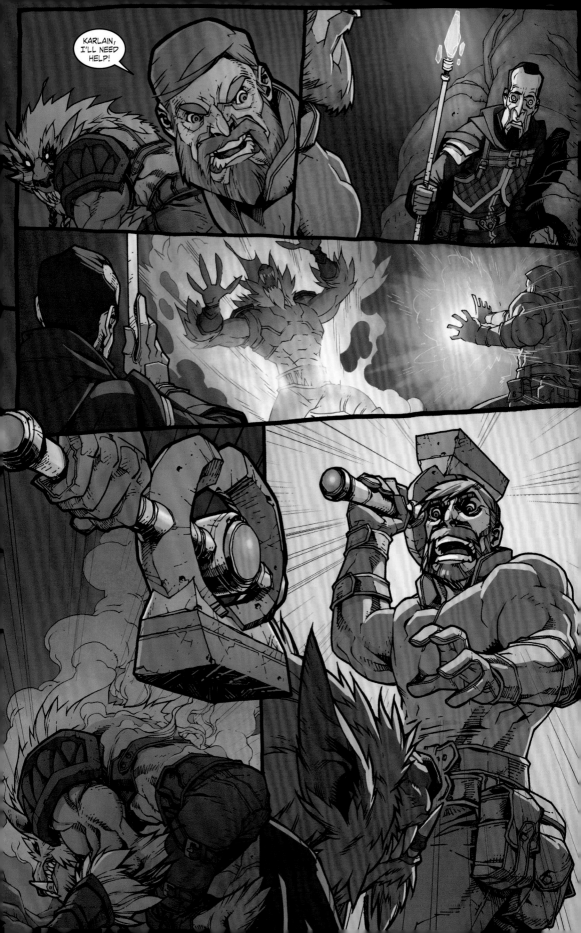

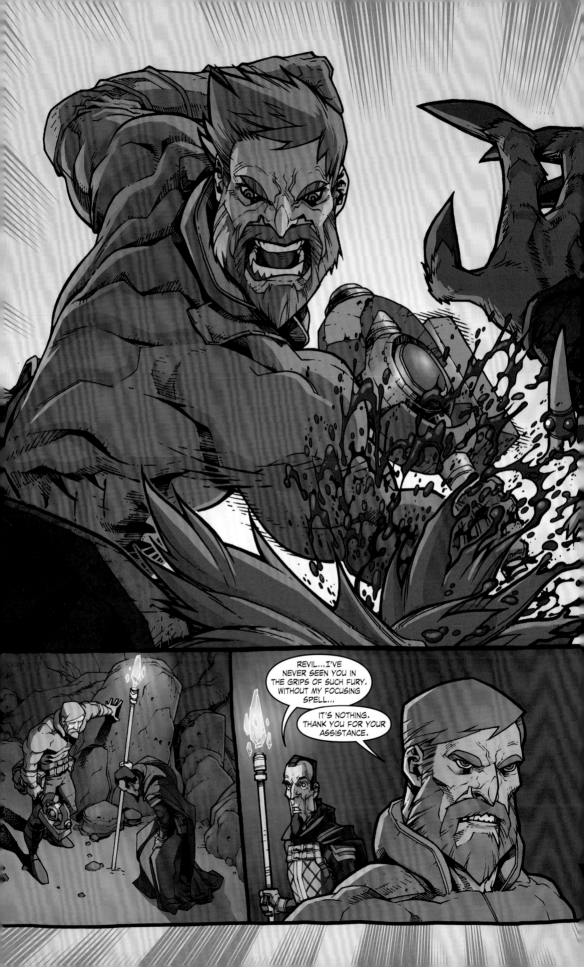

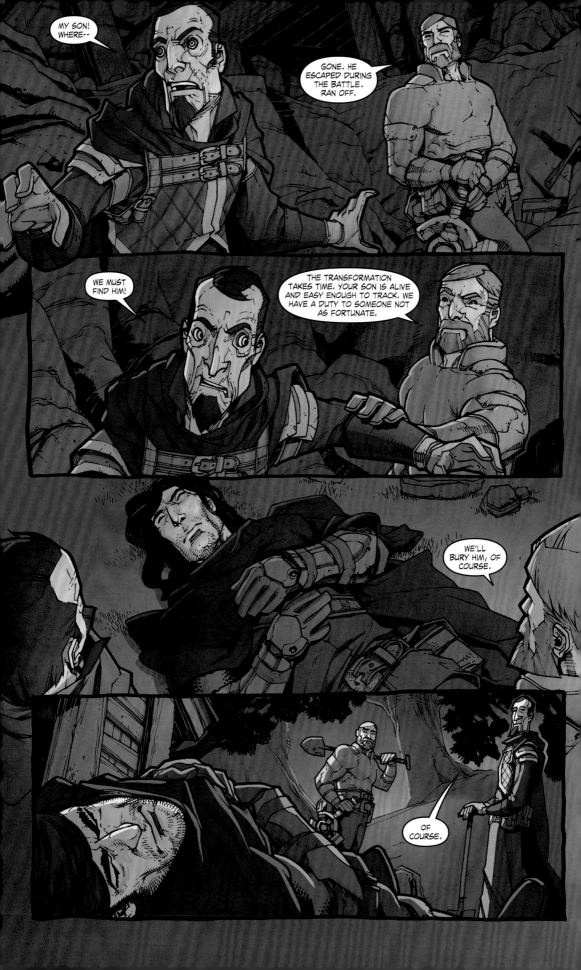

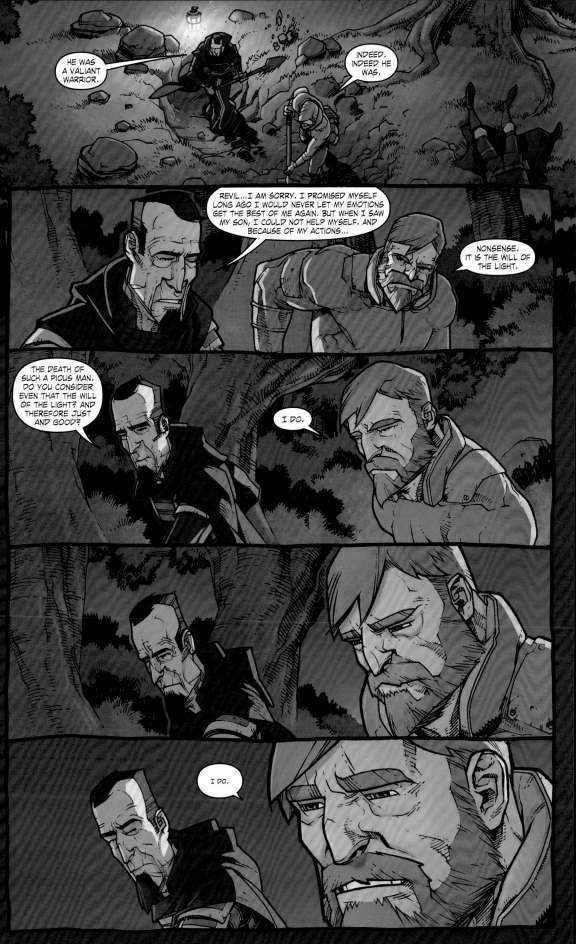

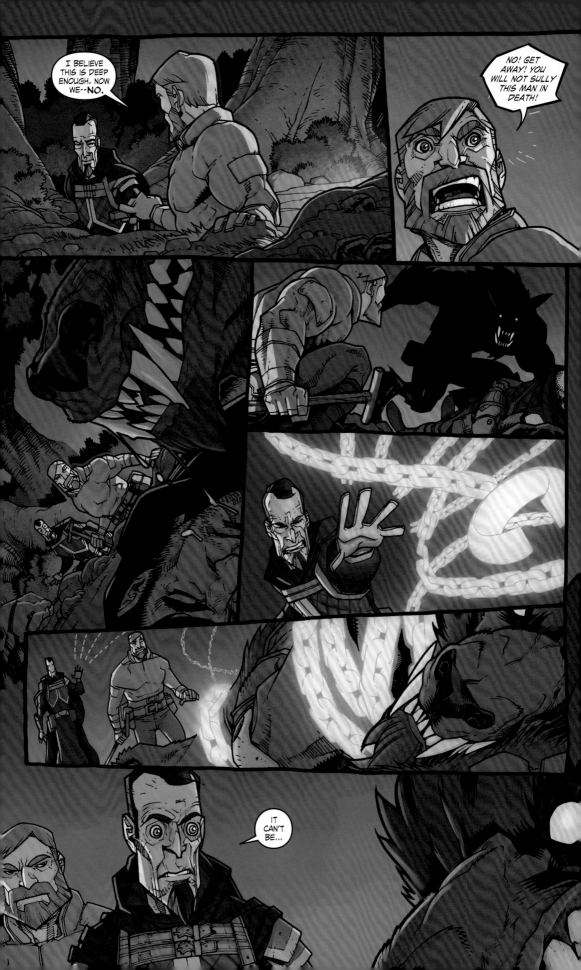

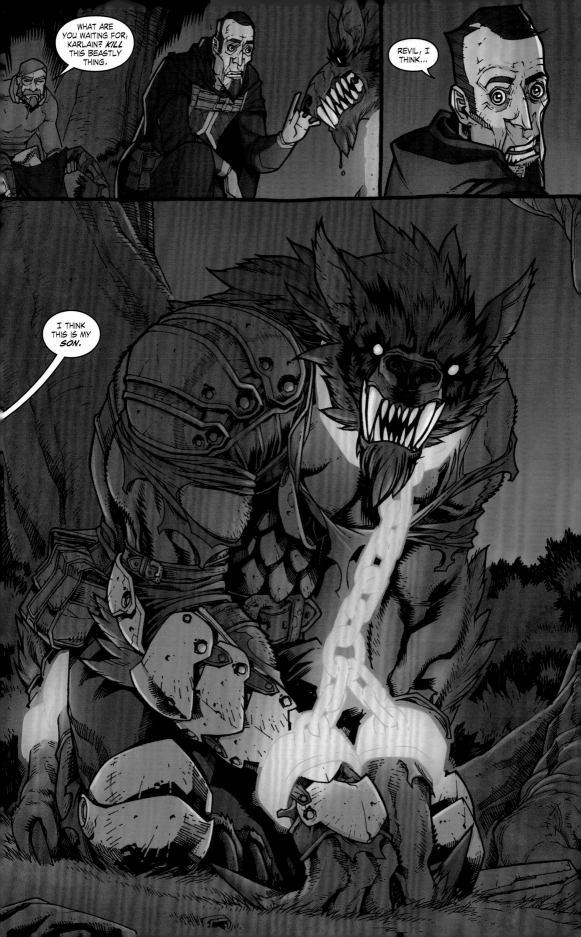

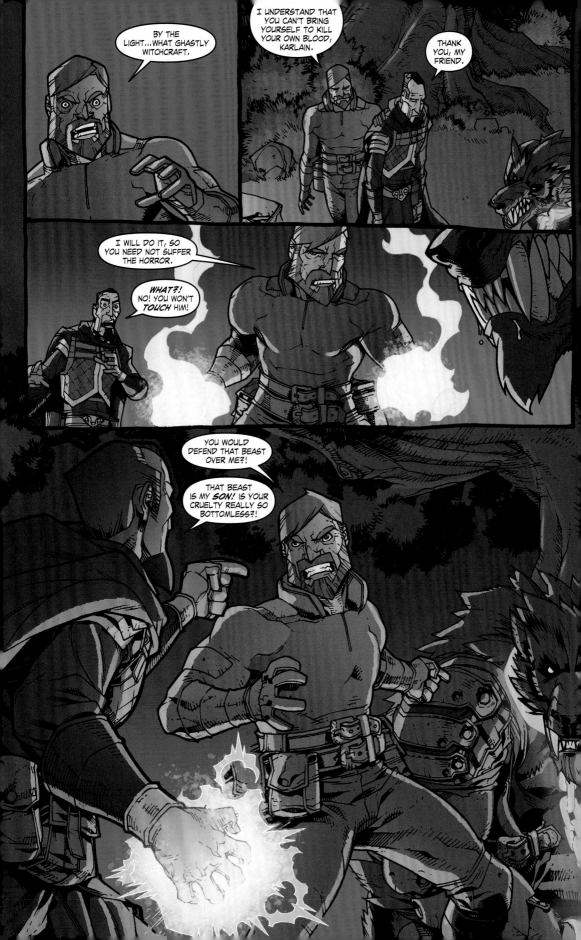

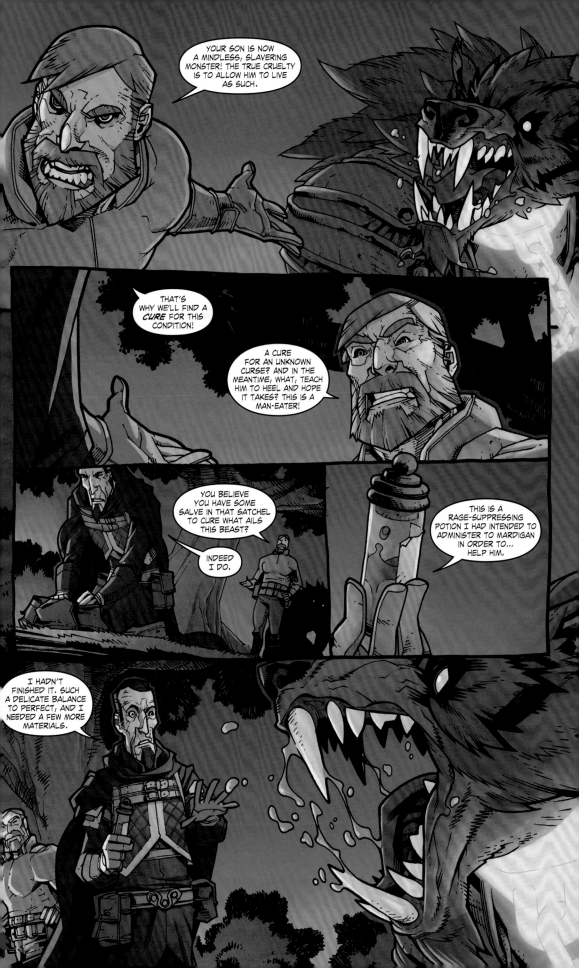

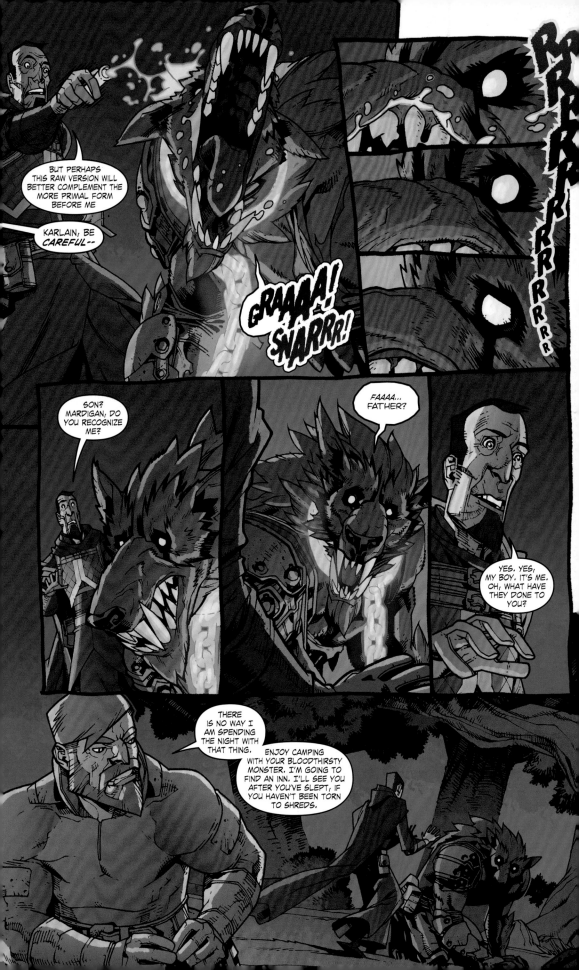

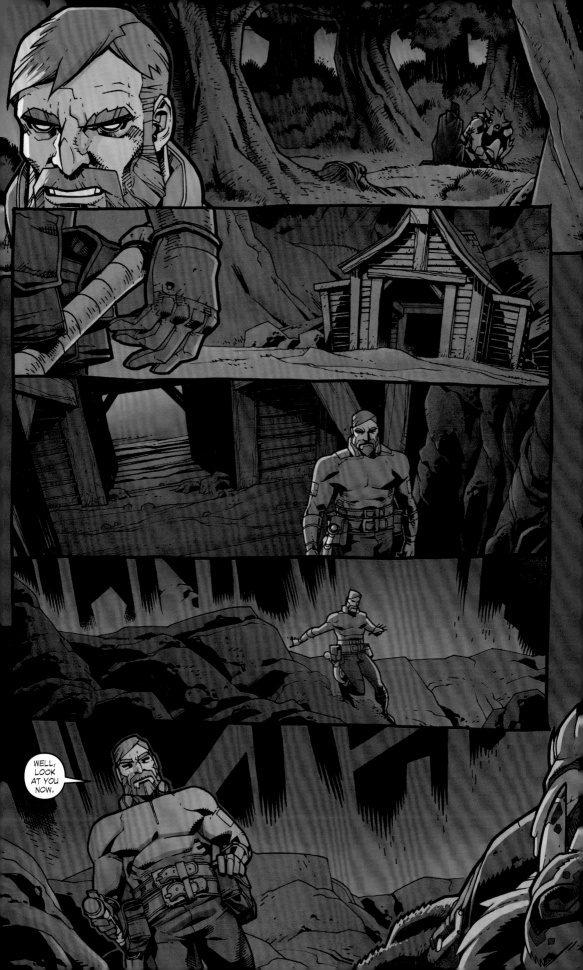

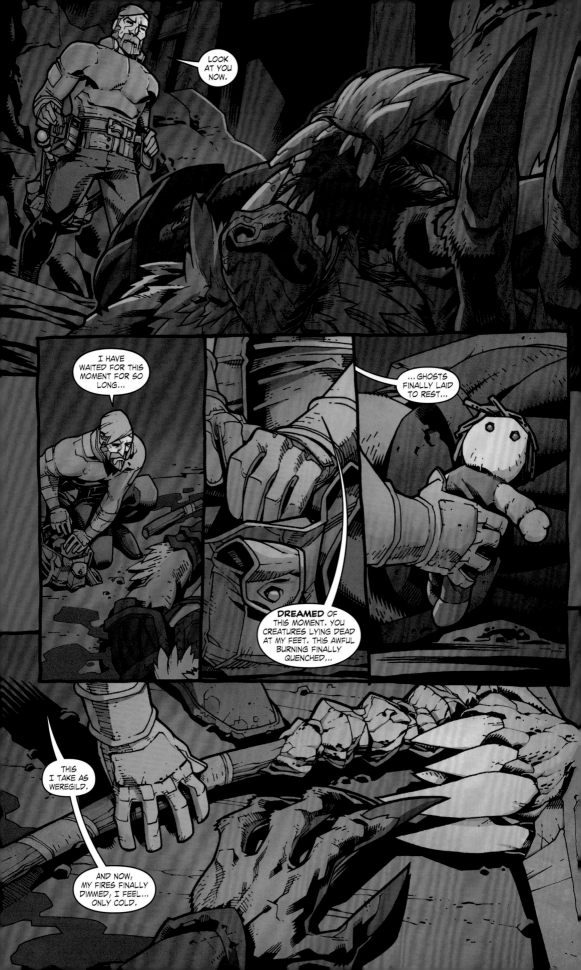

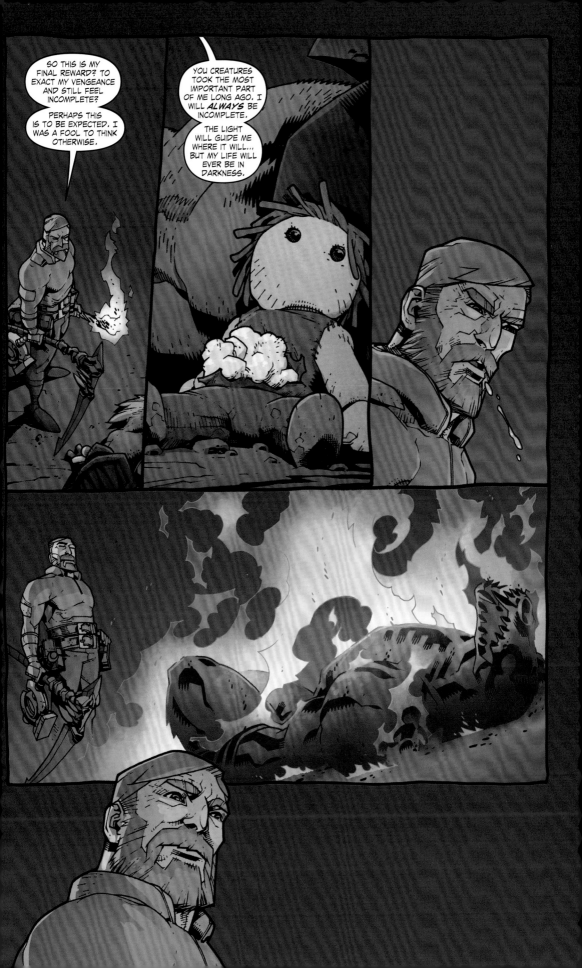

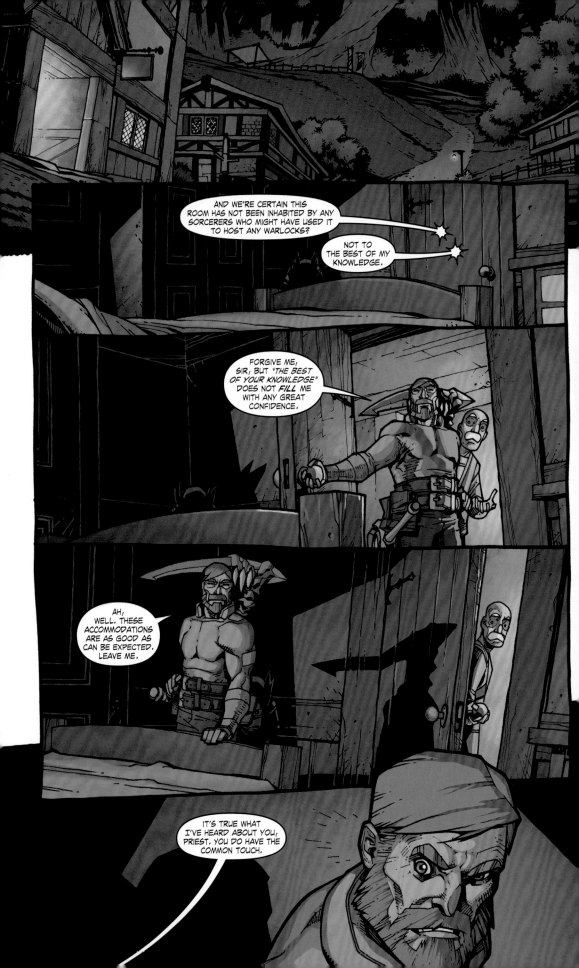

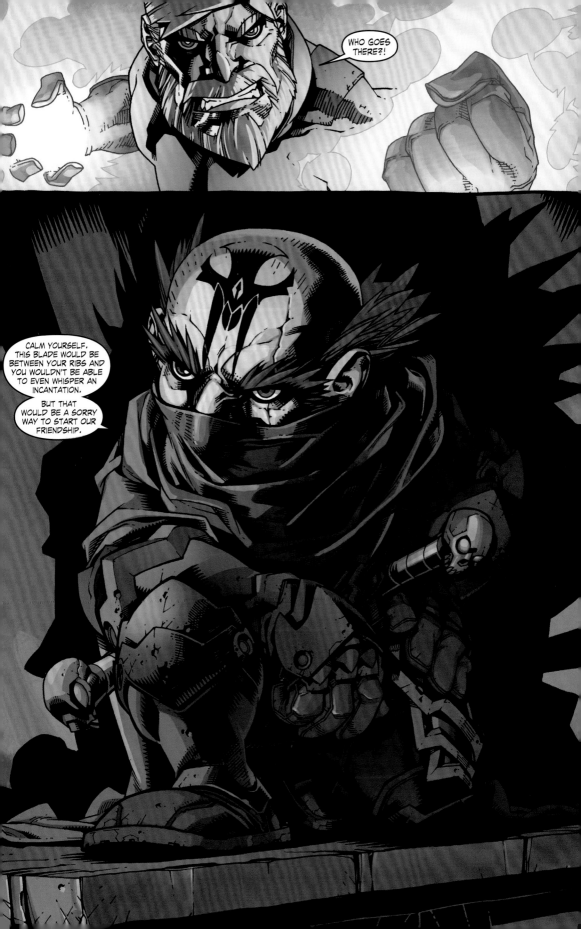

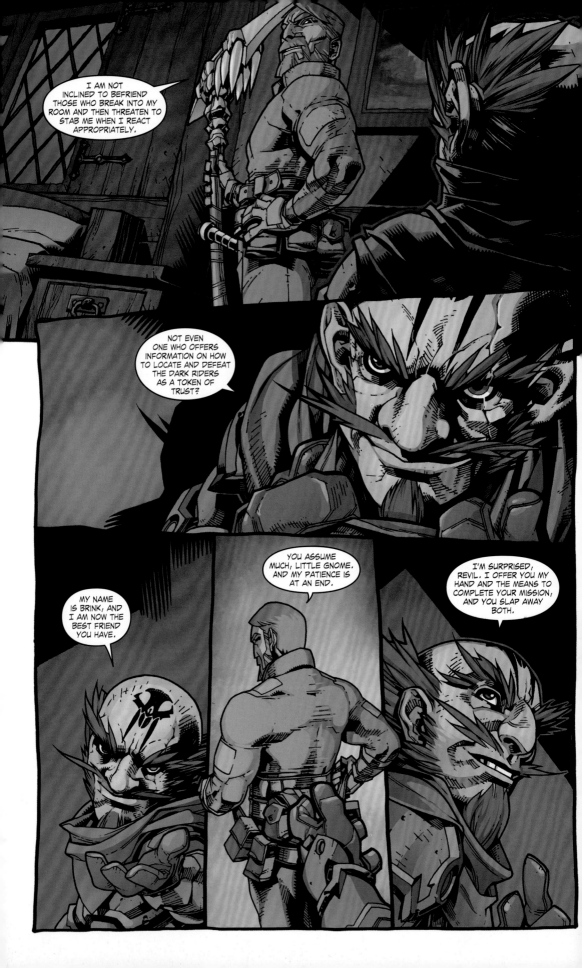

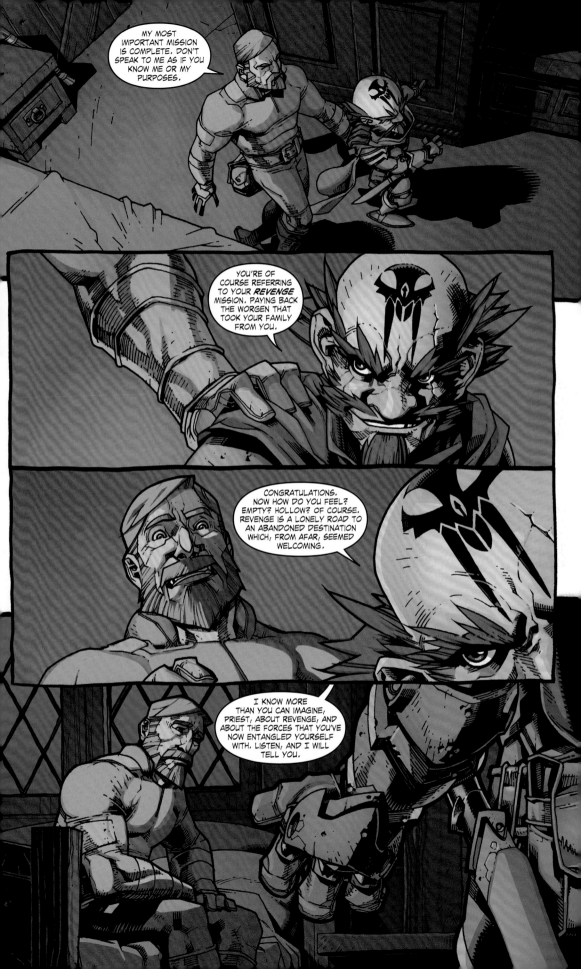

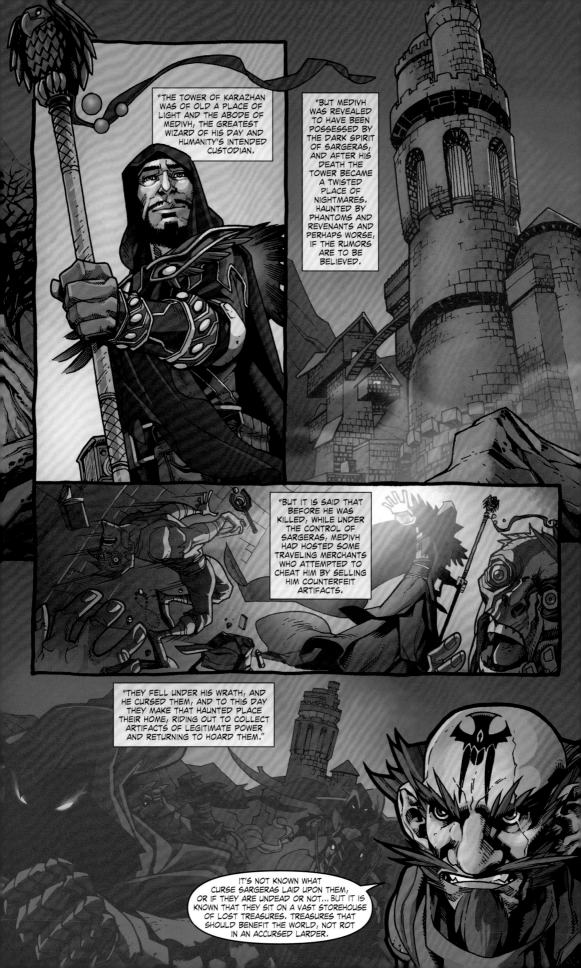

"THE TOWER OF KARAZHAN WAS OF OLD A PLACE OF LIGHT AND THE ABODE OF MEDIVH, THE GREATEST WIZARD OF HIS DAY AND HUMANITY'S INTENDED CUSTODIAN.

"BUT MEDIVH WAS REVEALED TO HAVE BEEN POSSESSED BY THE DARK SPIRIT OF SARGERAS, AND AFTER HIS DEATH THE TOWER BECAME A TWISTED PLACE OF NIGHTMARES, HAUNTED BY PHANTOMS AND REVENANTS AND PERHAPS WORSE, IF THE RUMORS ARE TO BE BELIEVED.

"BUT IT IS SAID THAT BEFORE HE WAS KILLED, WHILE UNDER THE CONTROL OF SARGERAS, MEDIVH HAD HOSTED SOME TRAVELING MERCHANTS WHO ATTEMPTED TO CHEAT HIM BY SELLING HIM COUNTERFEIT ARTIFACTS.

"THEY FELL UNDER HIS WRATH, AND HE CURSED THEM, AND TO THIS DAY THEY MAKE THAT HAUNTED PLACE THEIR HOME, RIDING OUT TO COLLECT ARTIFACTS OF LEGITIMATE POWER AND RETURNING TO HOARD THEM."

IT'S NOT KNOWN WHAT CURSE SARGERAS LAID UPON THEM, OR IF THEY ARE UNDEAD OR NOT... BUT IT IS KNOWN THAT THEY SIT ON A VAST STOREHOUSE OF LOST TREASURES. TREASURES THAT SHOULD BENEFIT THE WORLD, NOT ROT IN AN ACCURSED LARDER.

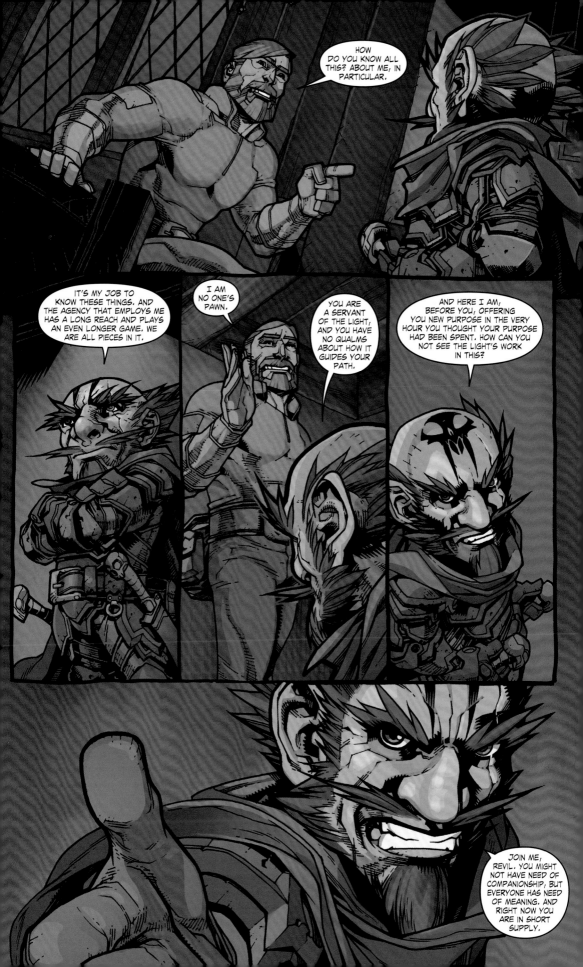

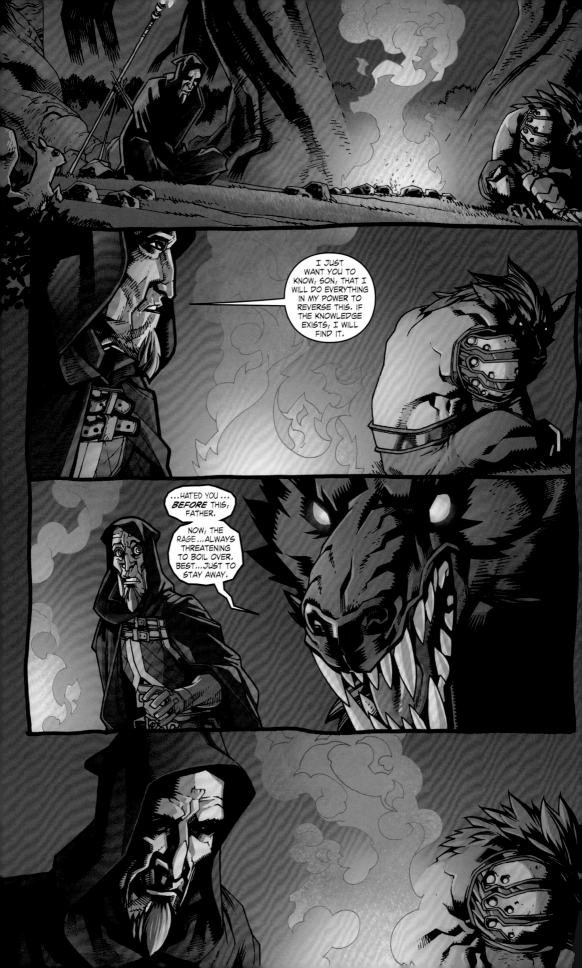

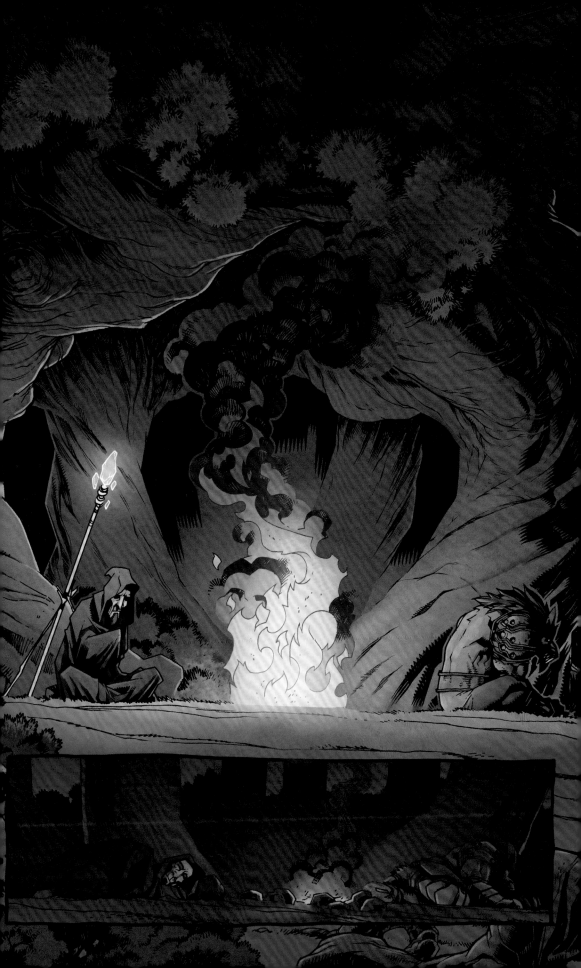

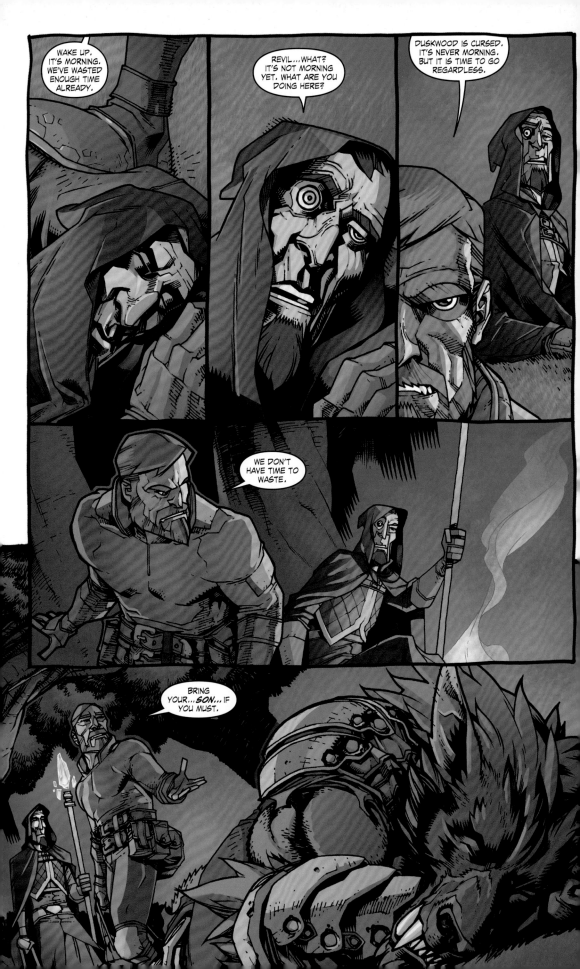

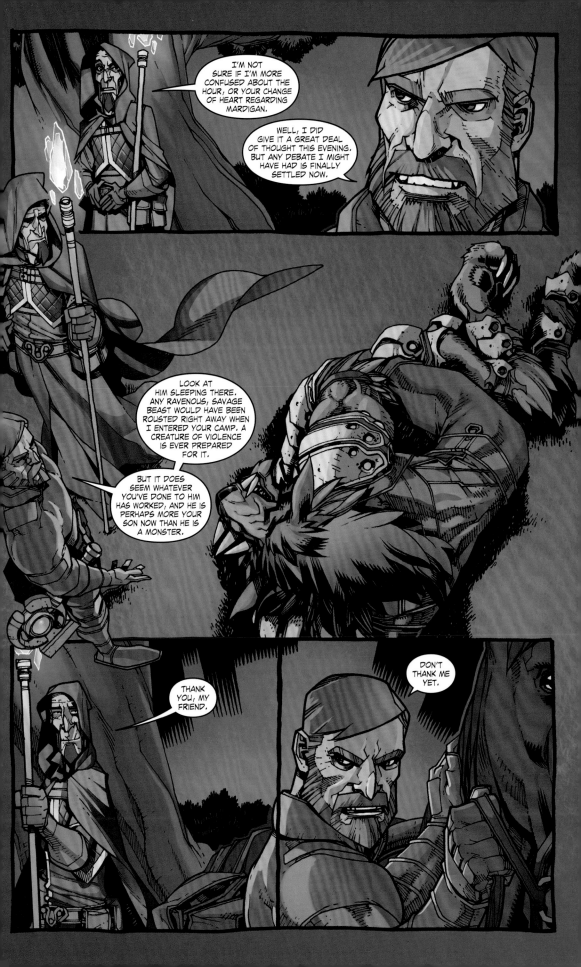

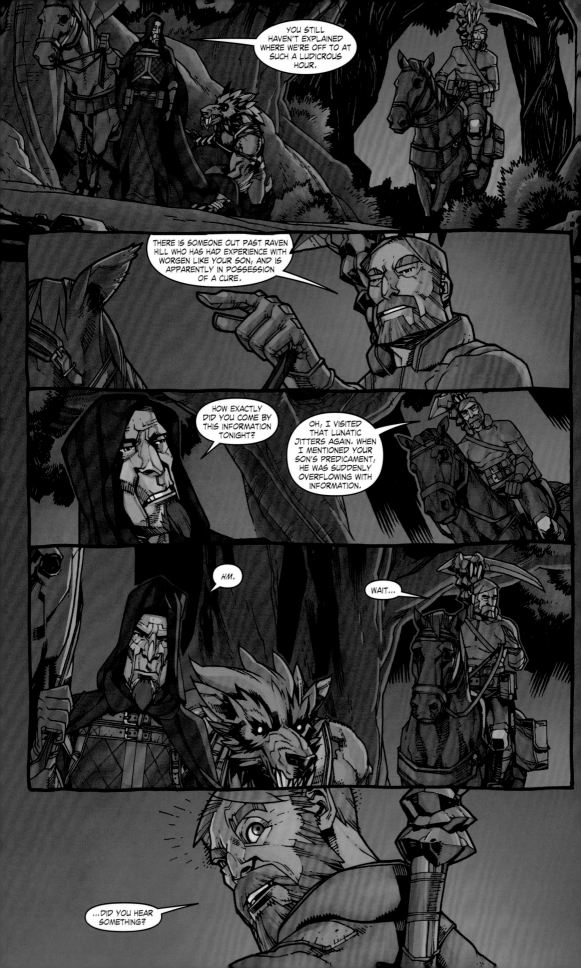

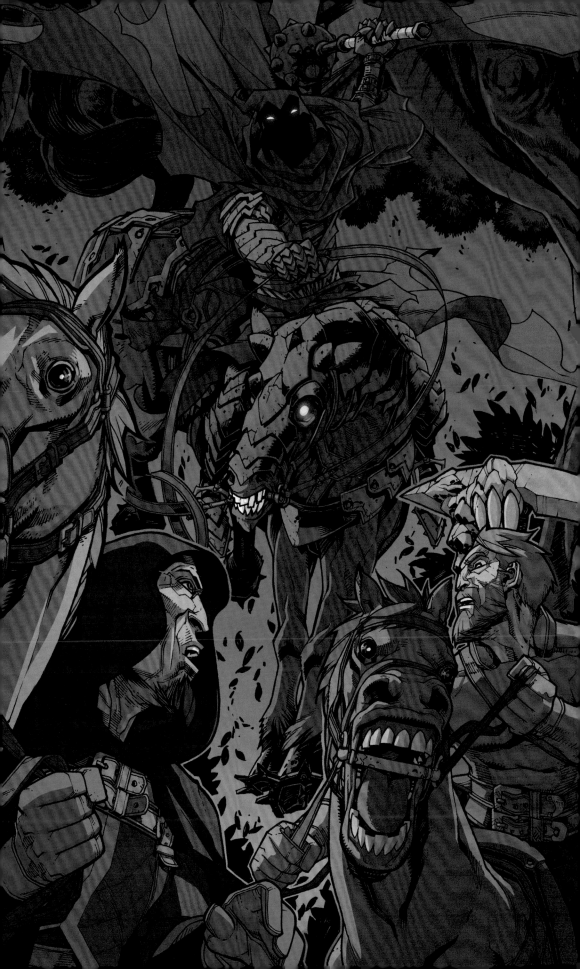

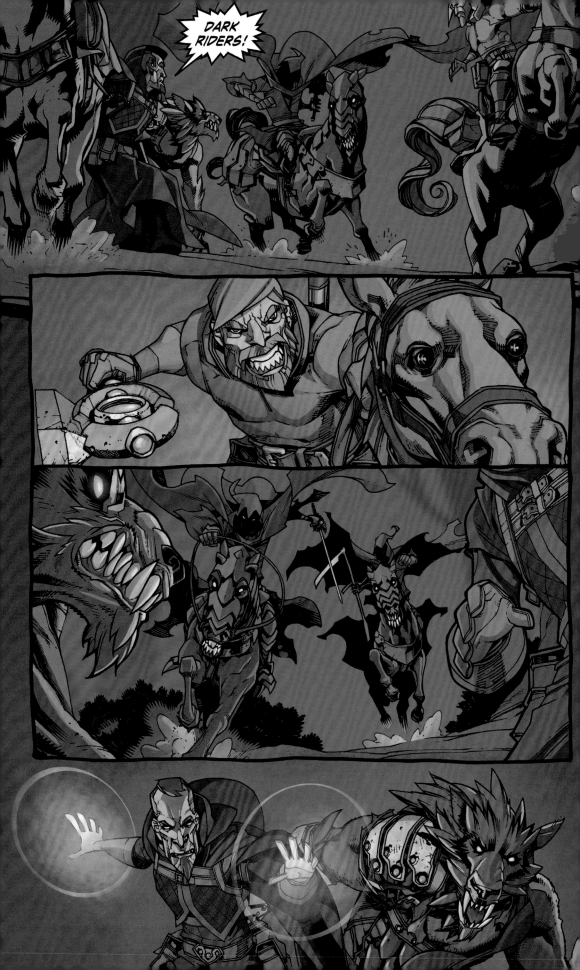

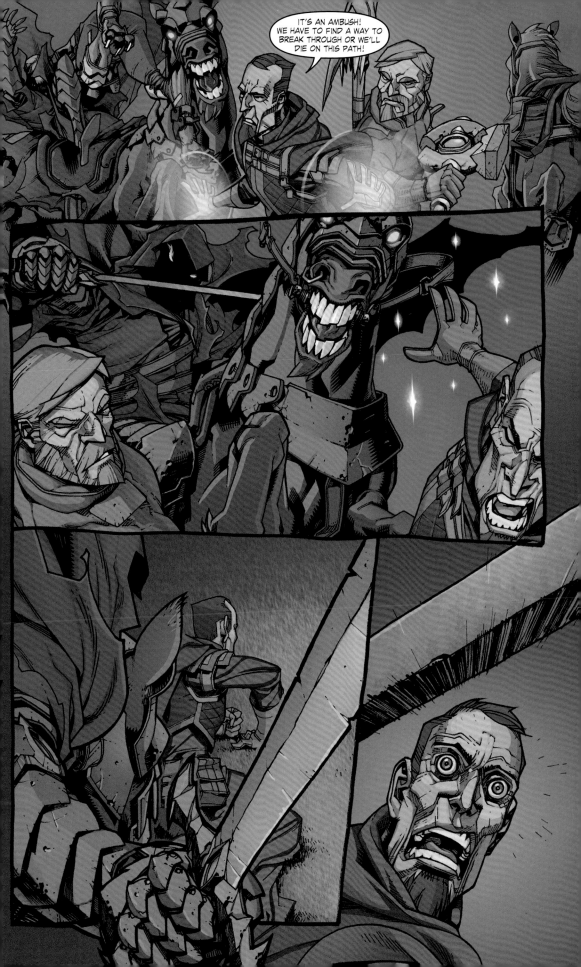

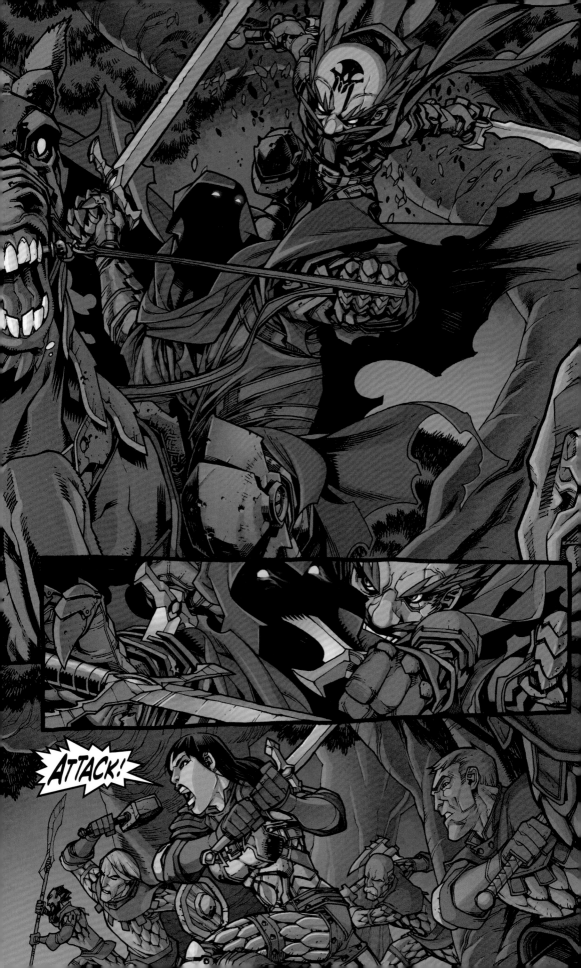

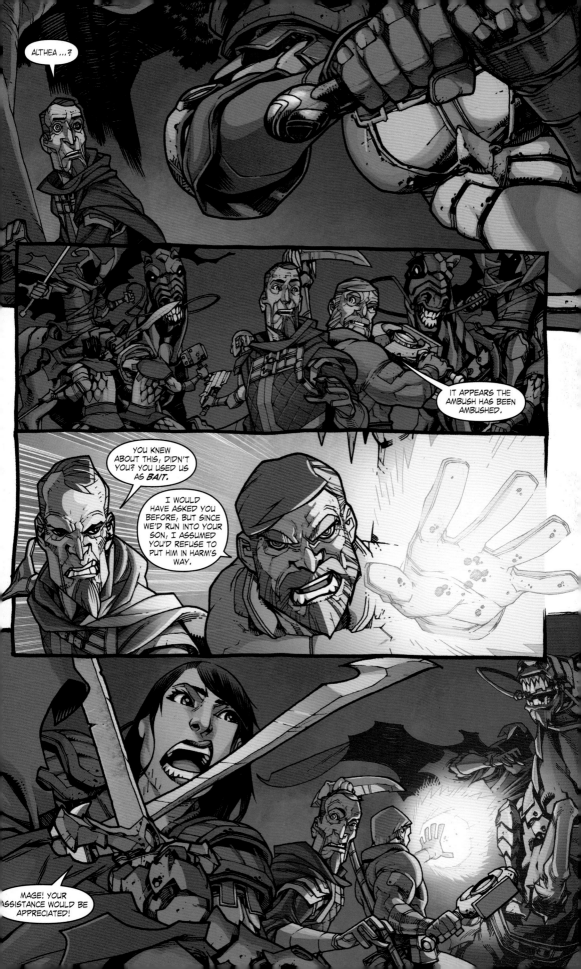

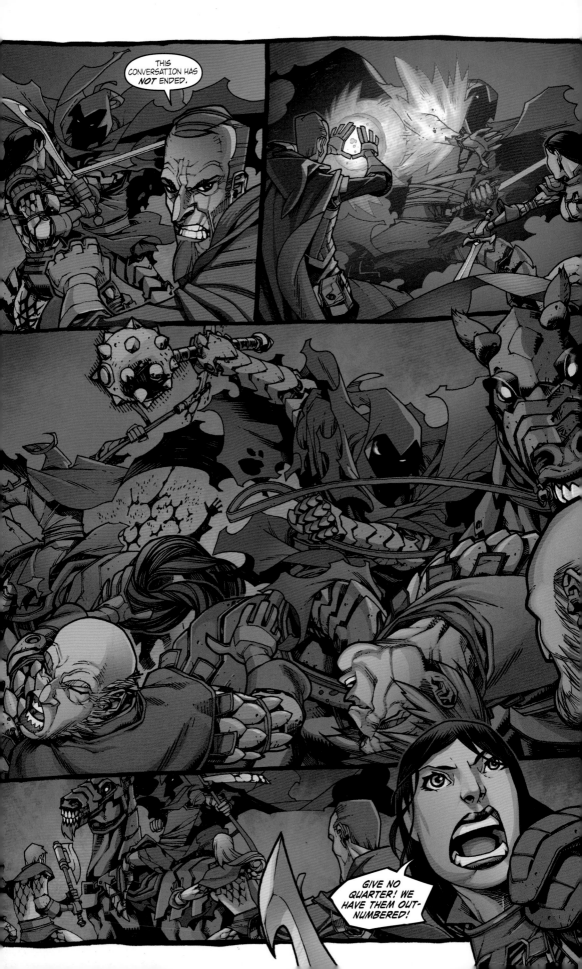

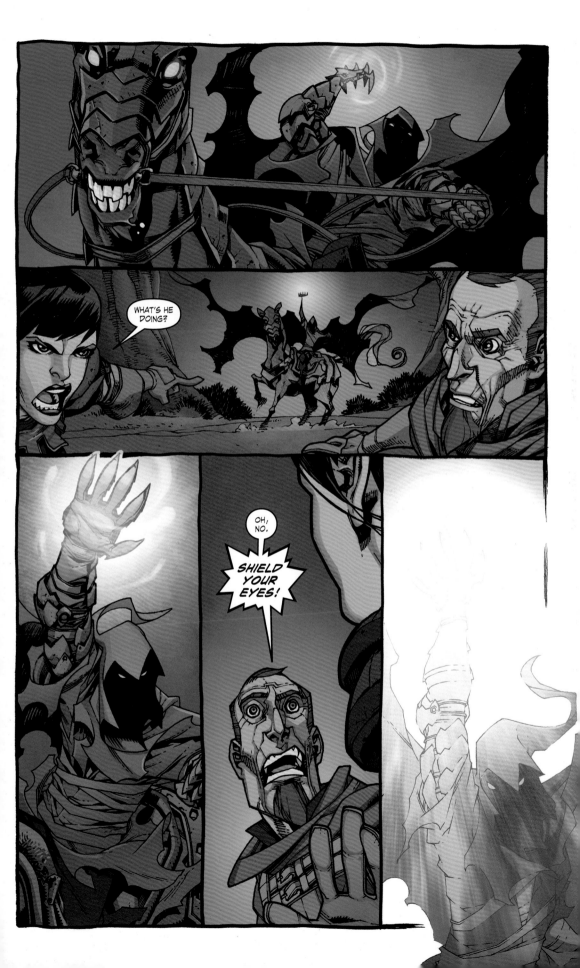

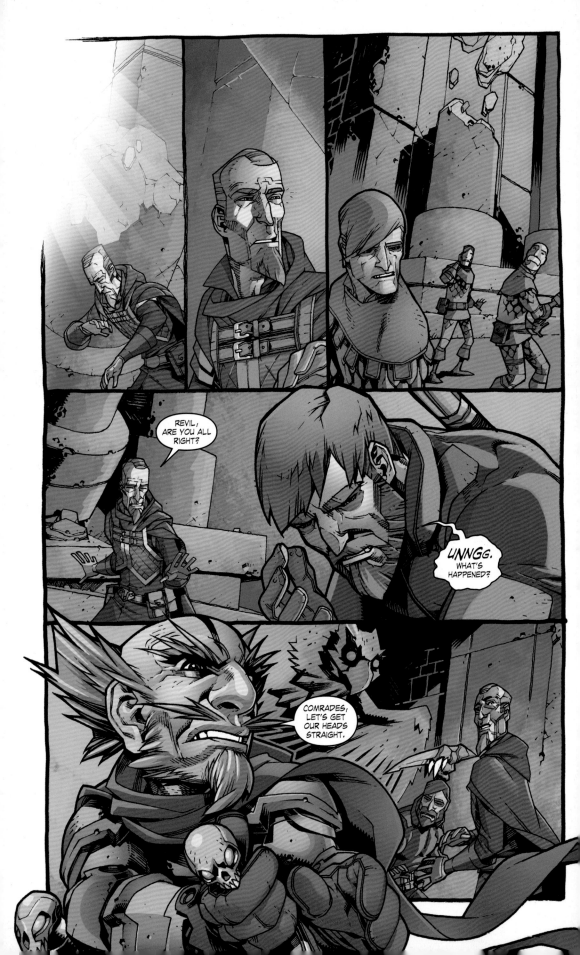

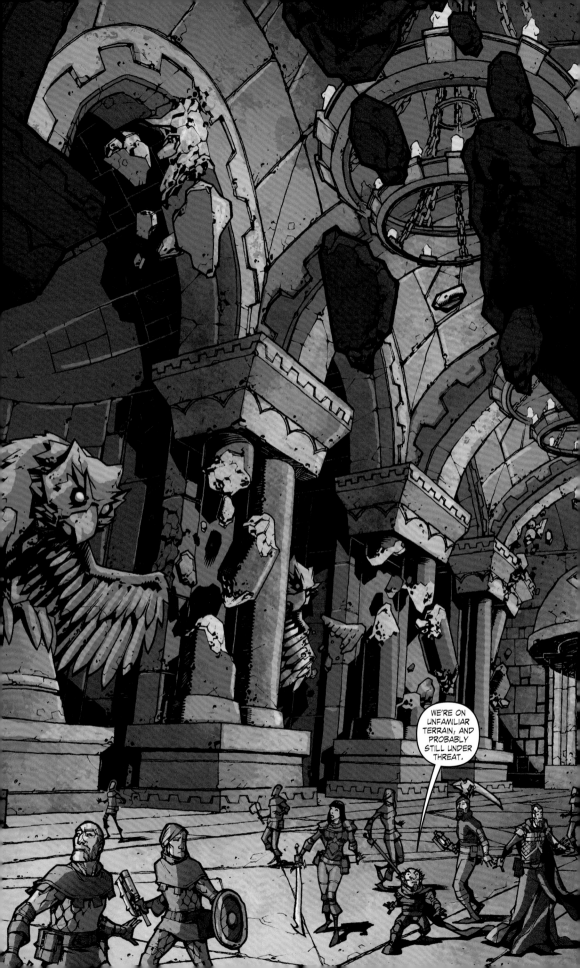

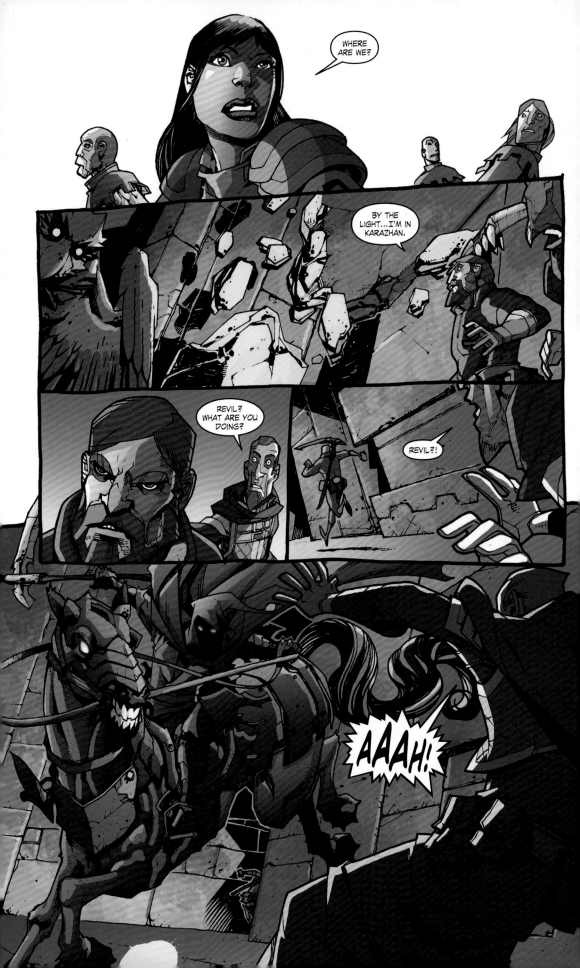

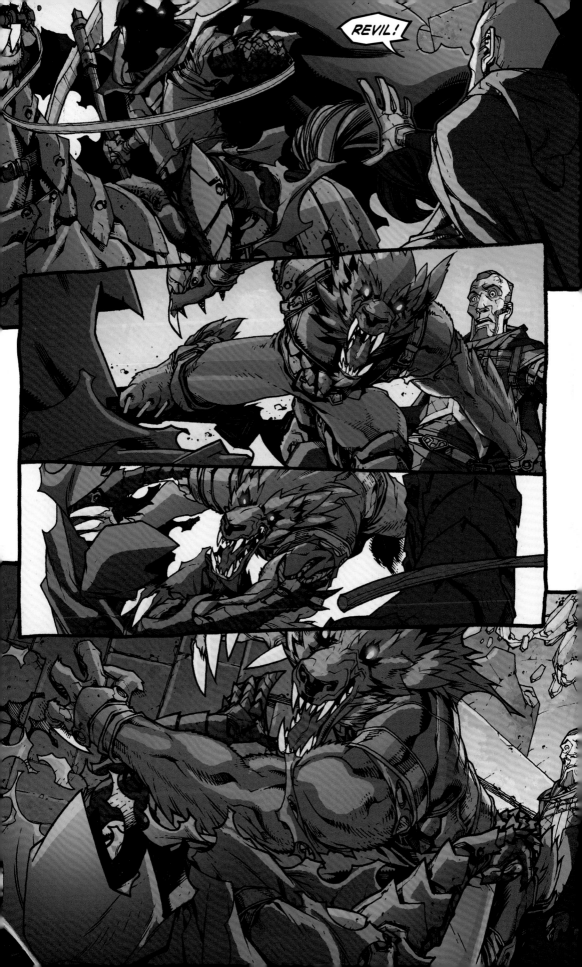

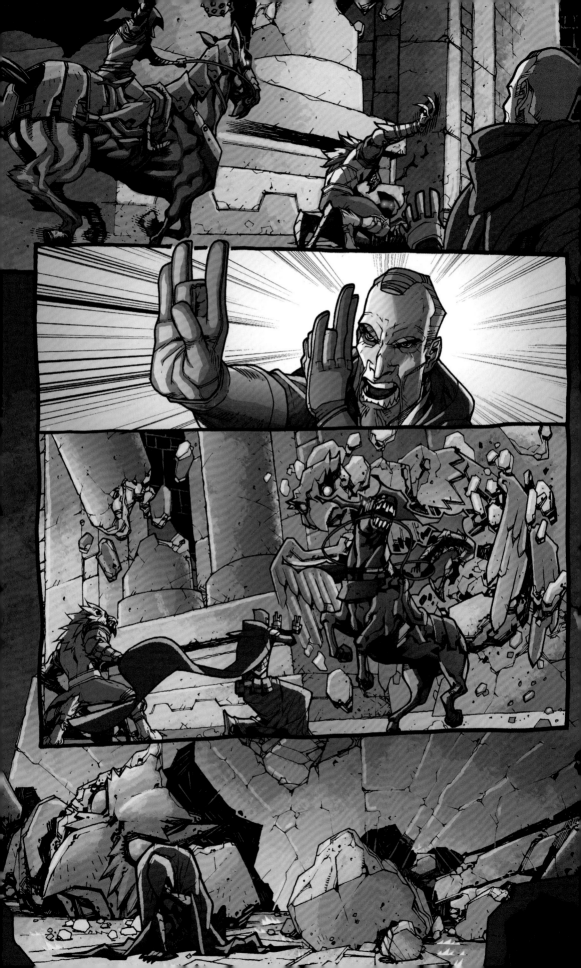

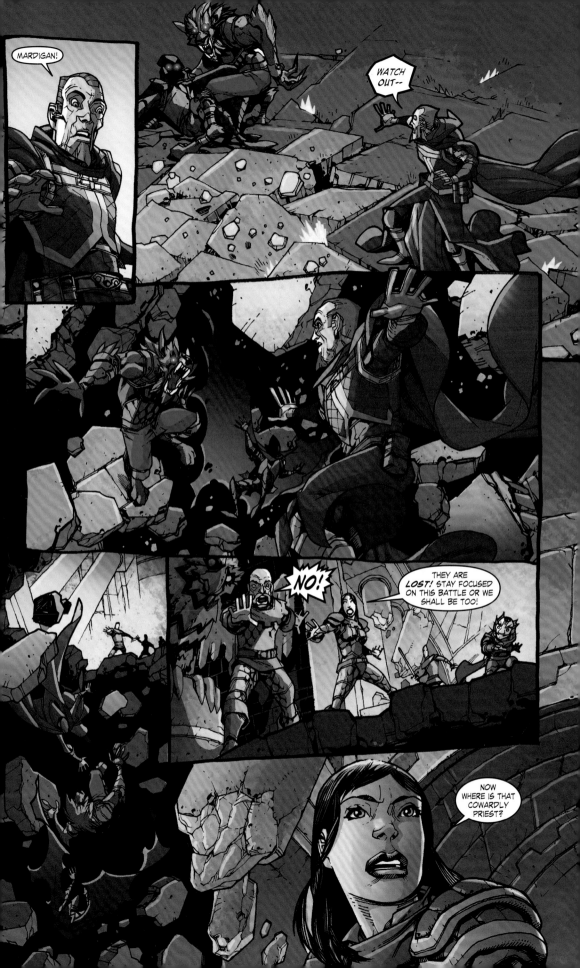

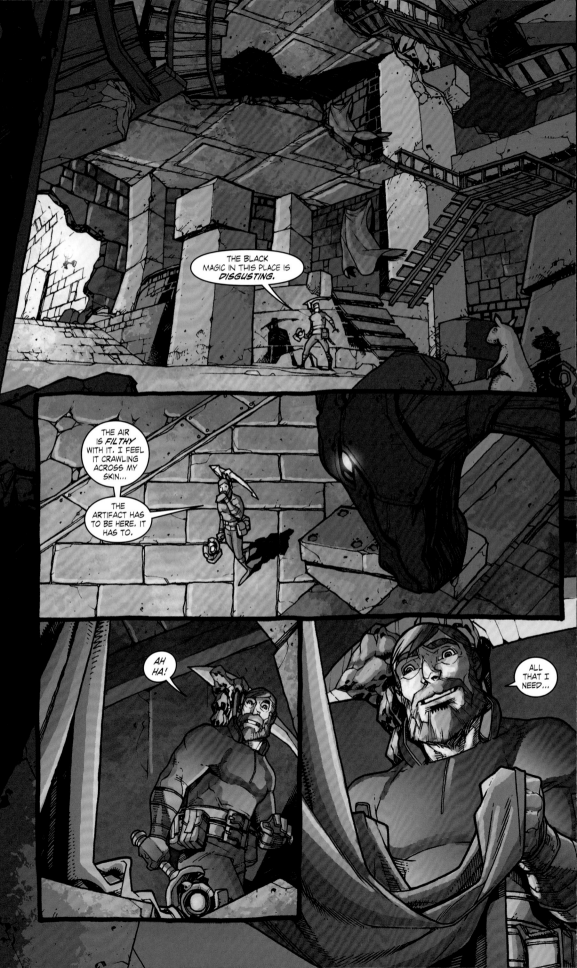

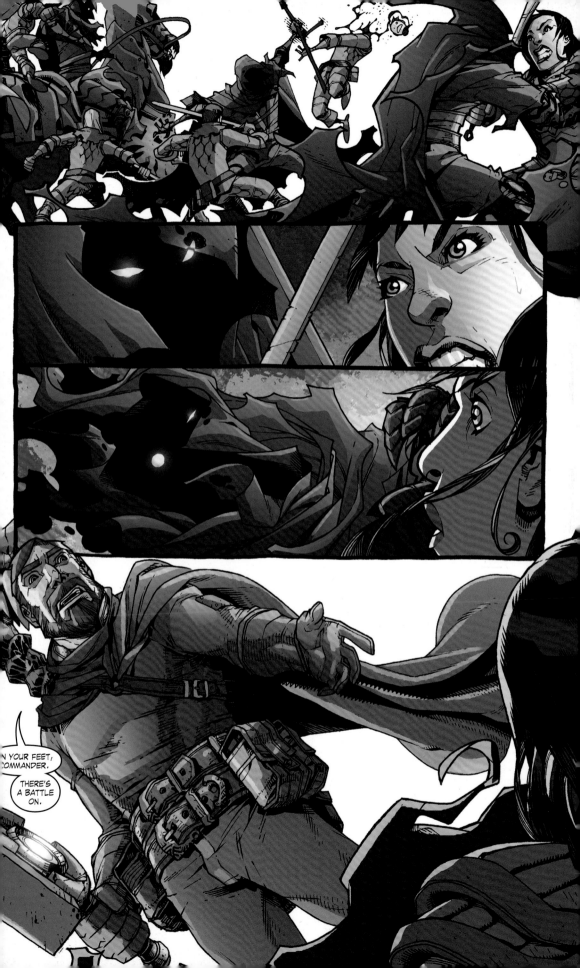

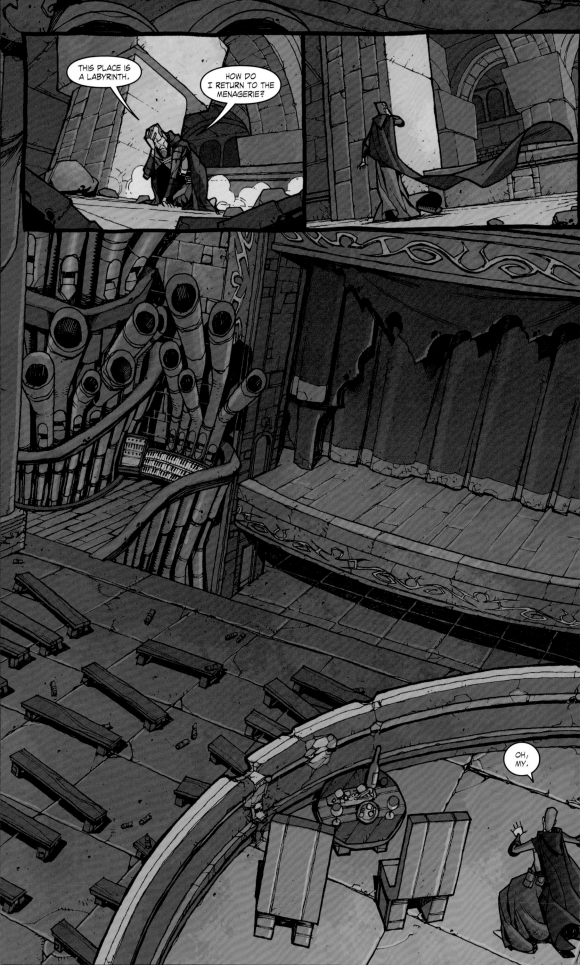

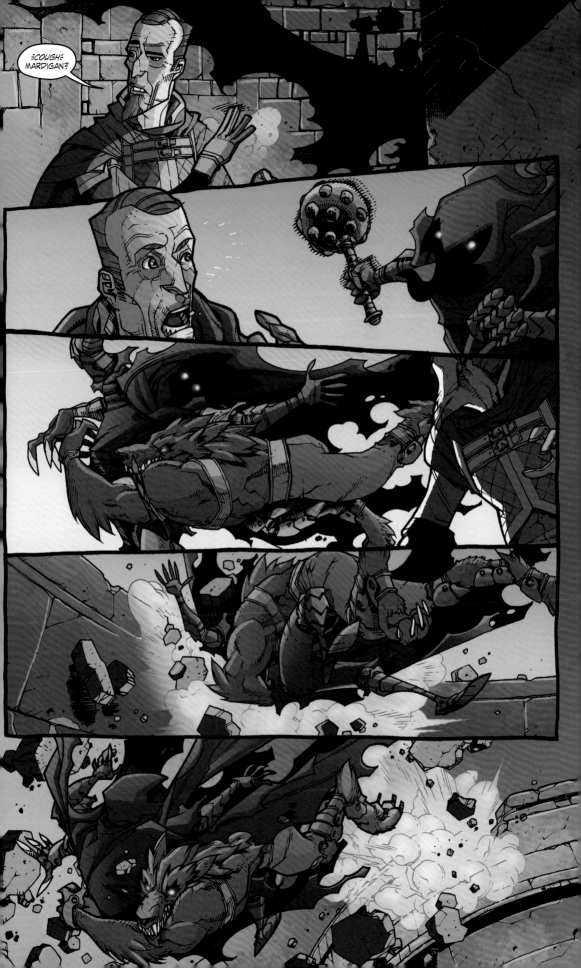

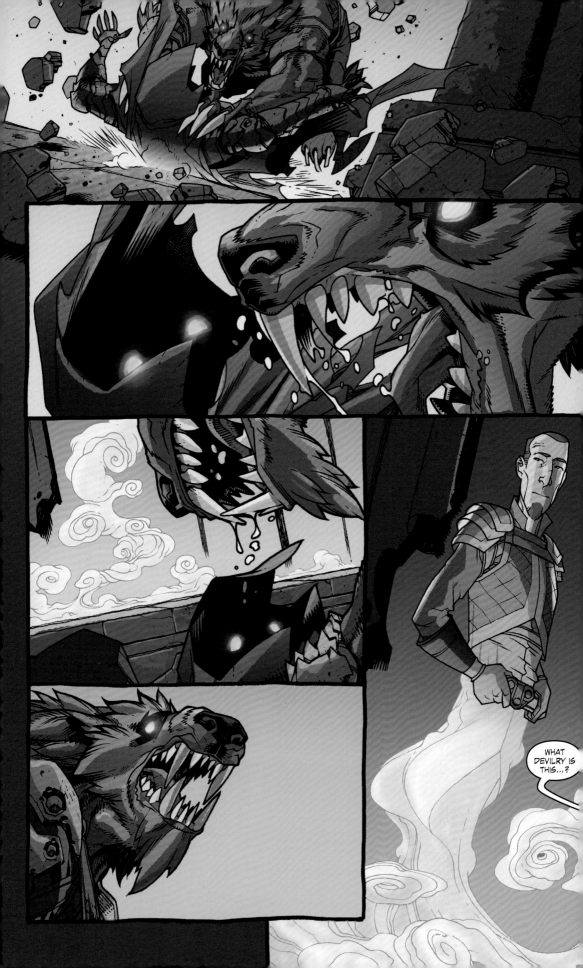

WHAT DEVILRY IS THIS...?

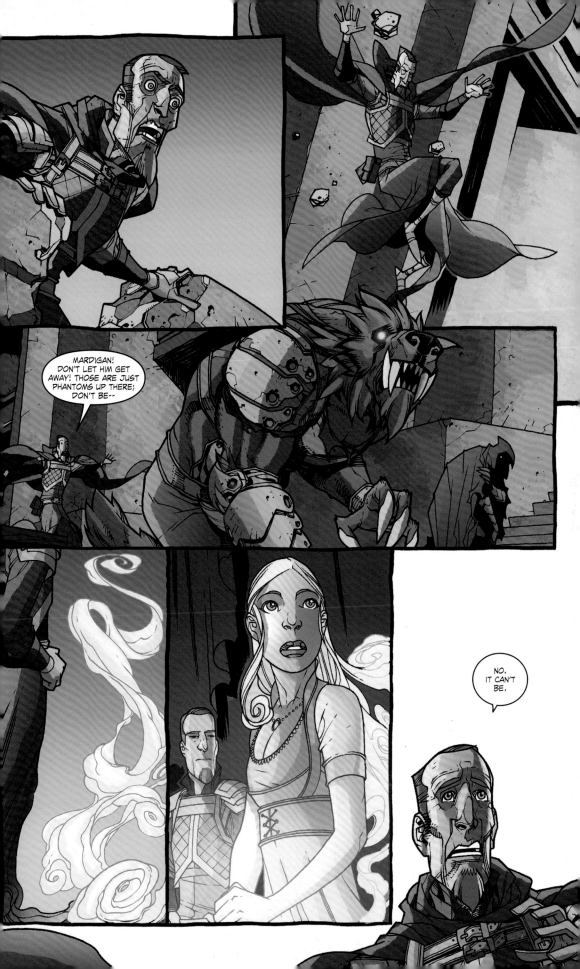

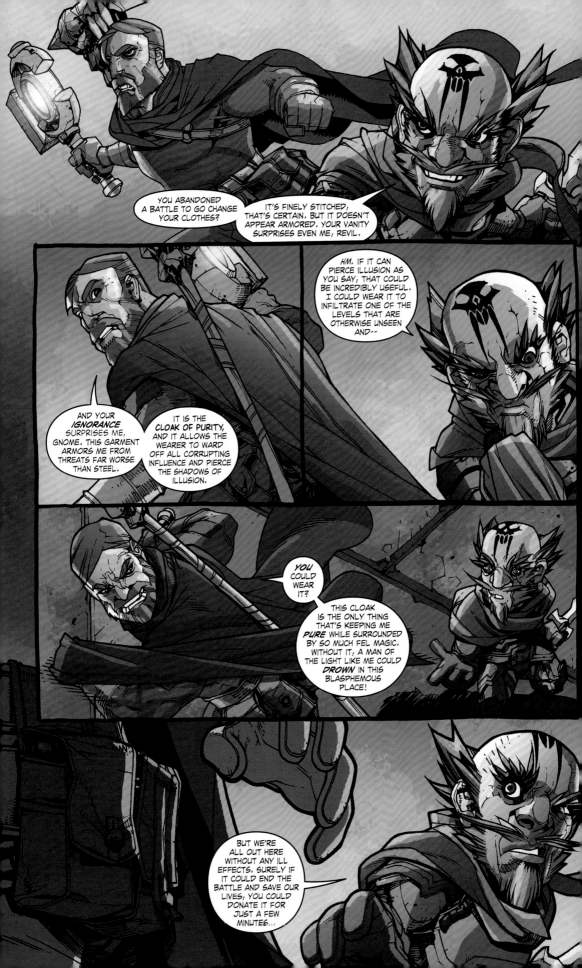

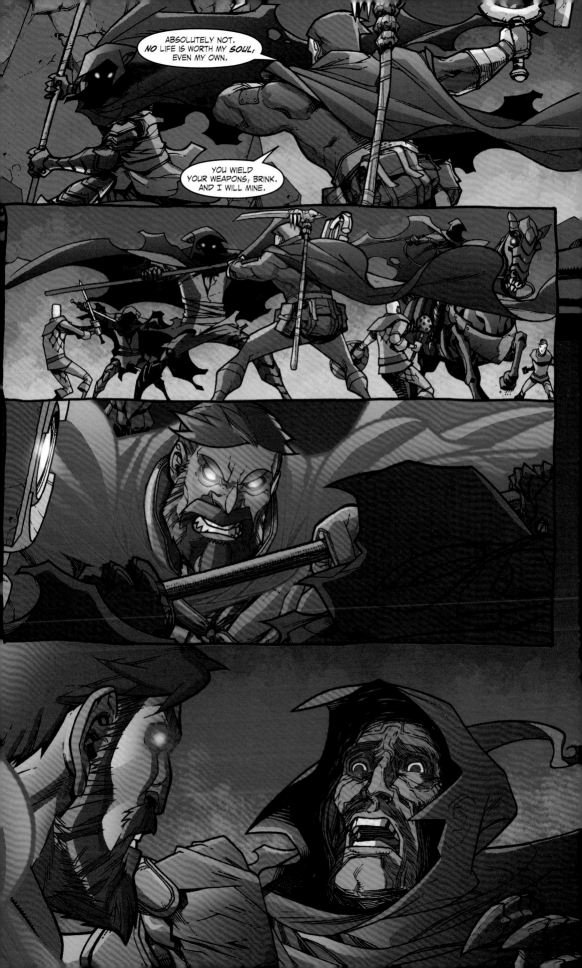

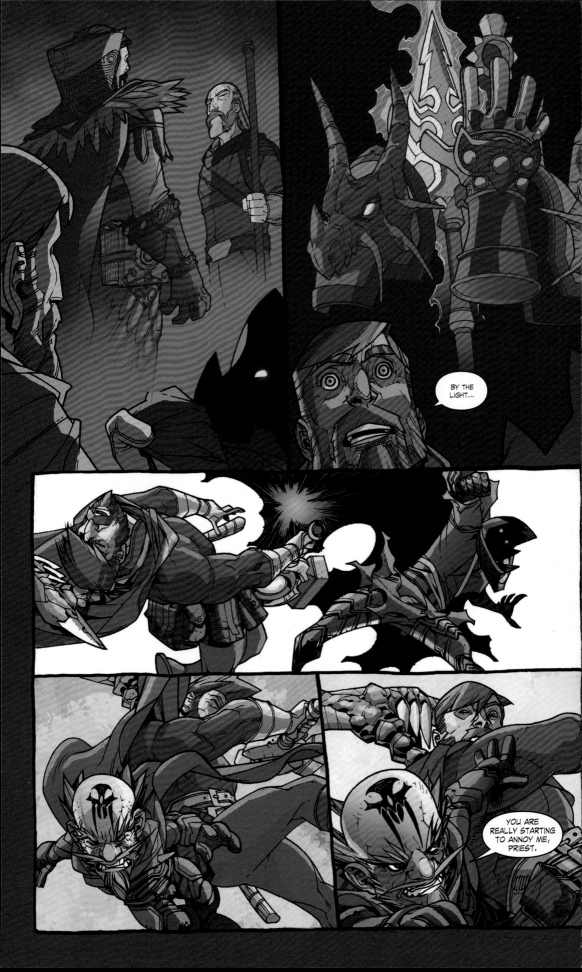

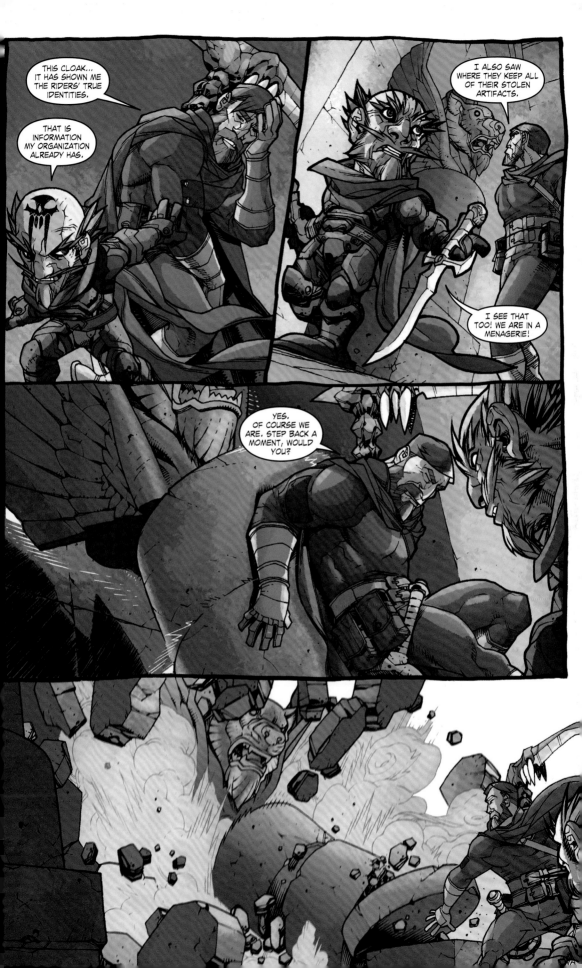

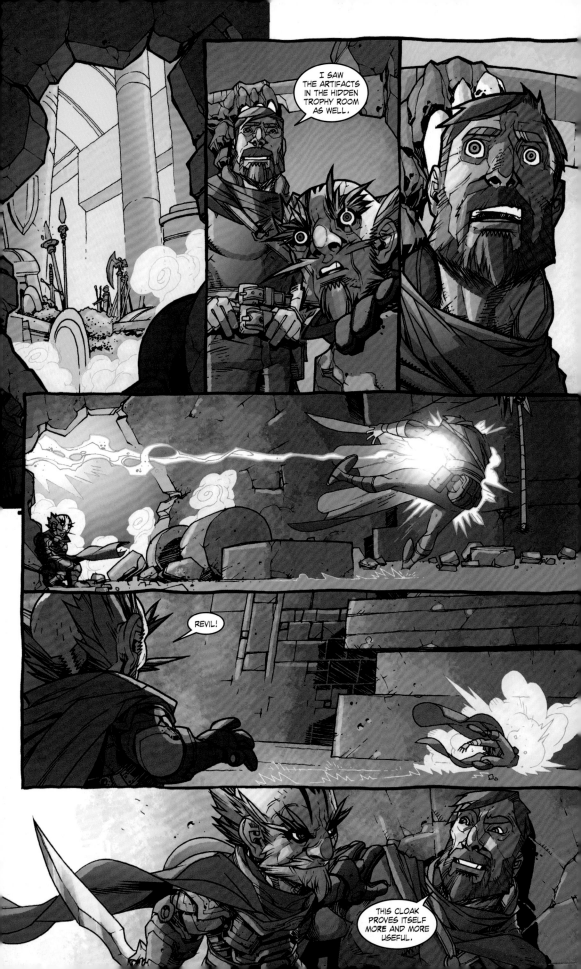

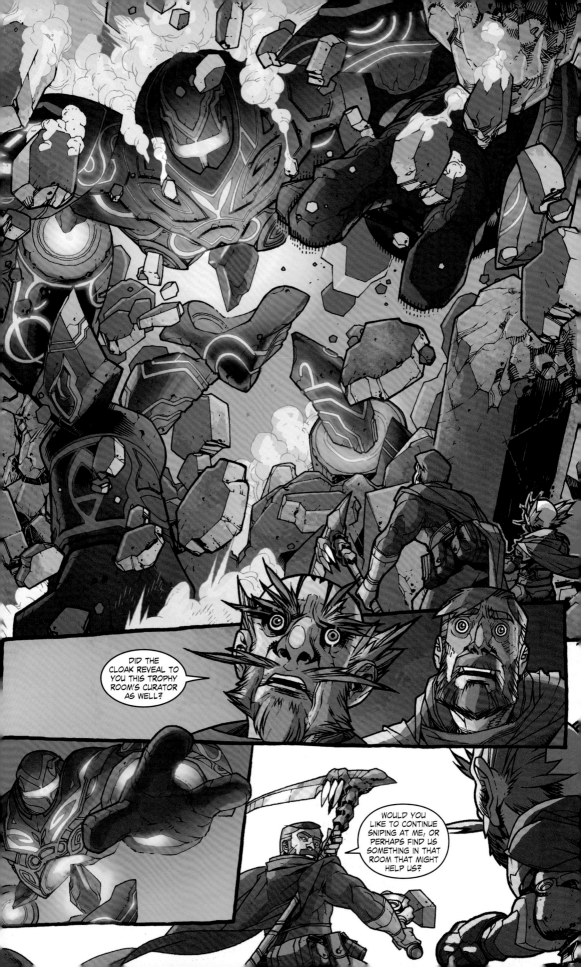

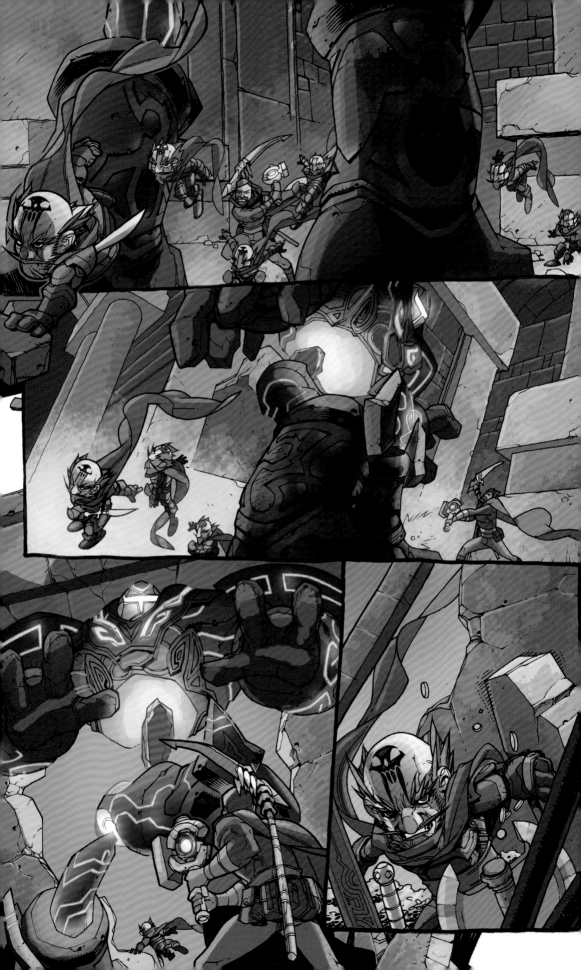

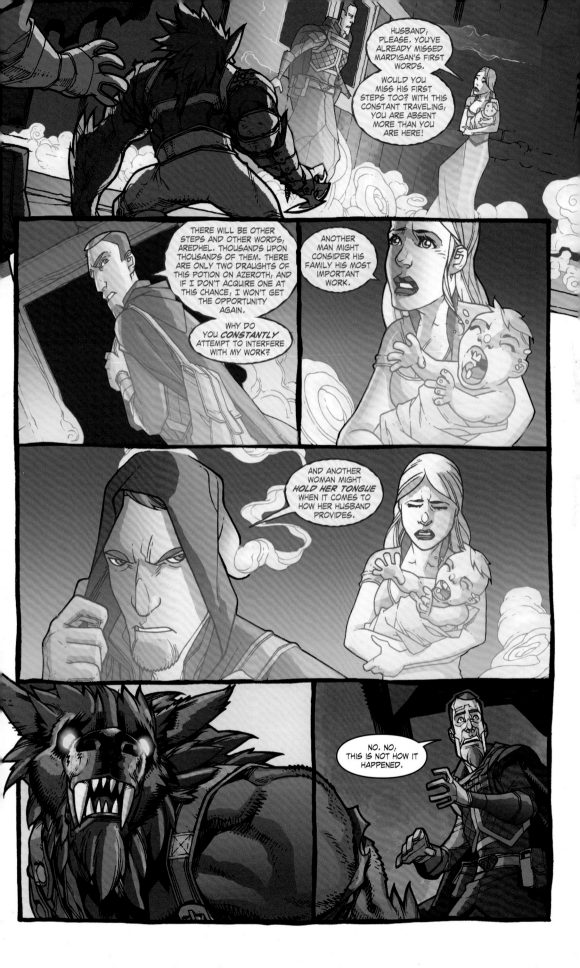

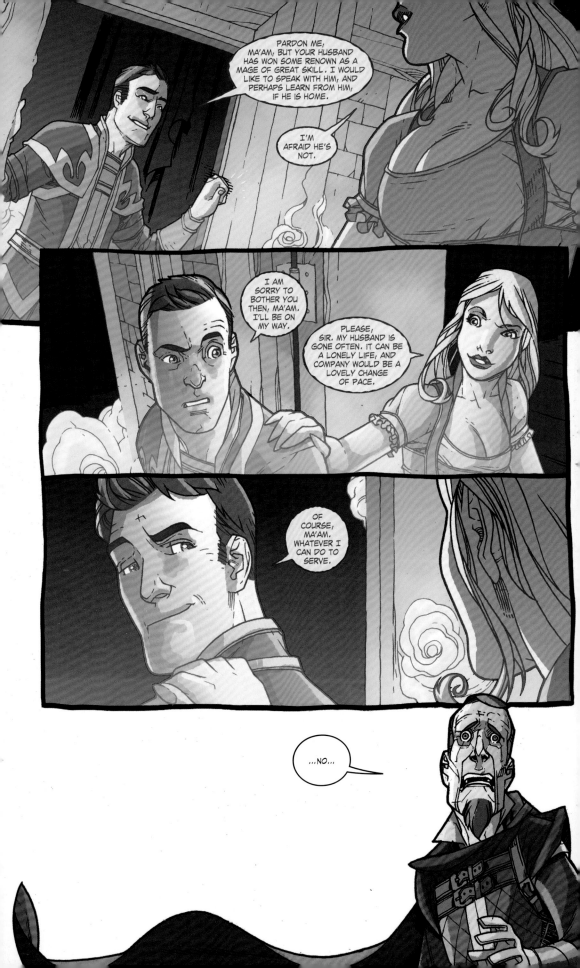

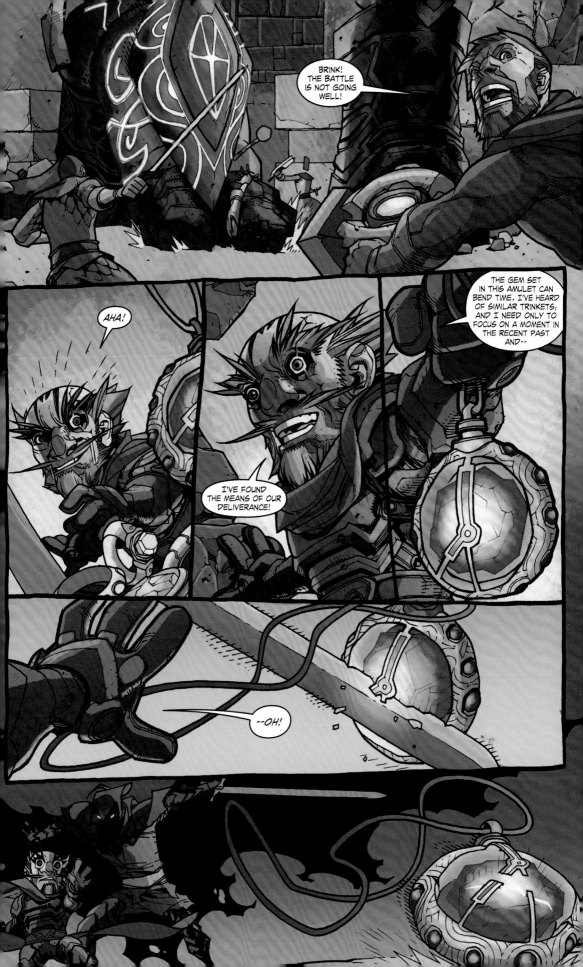

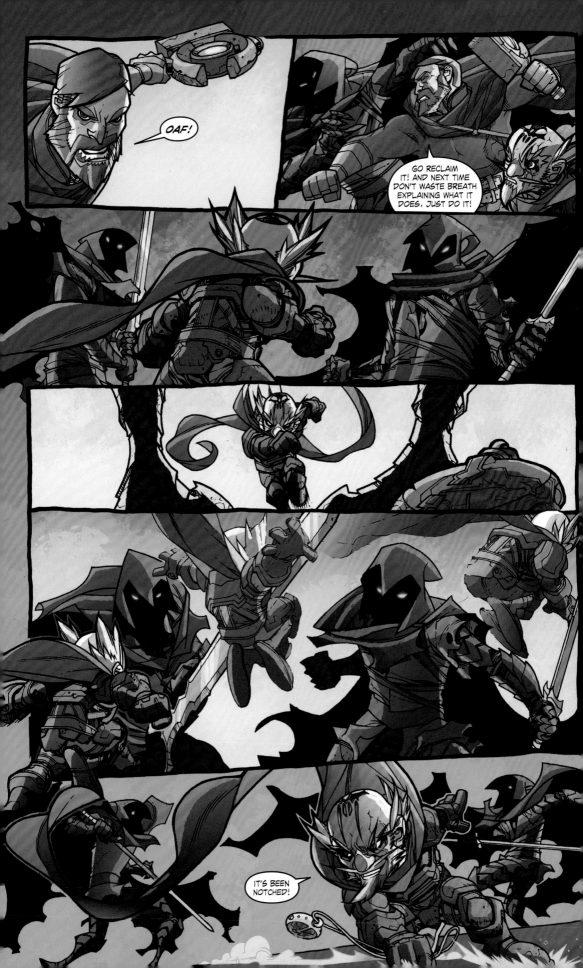

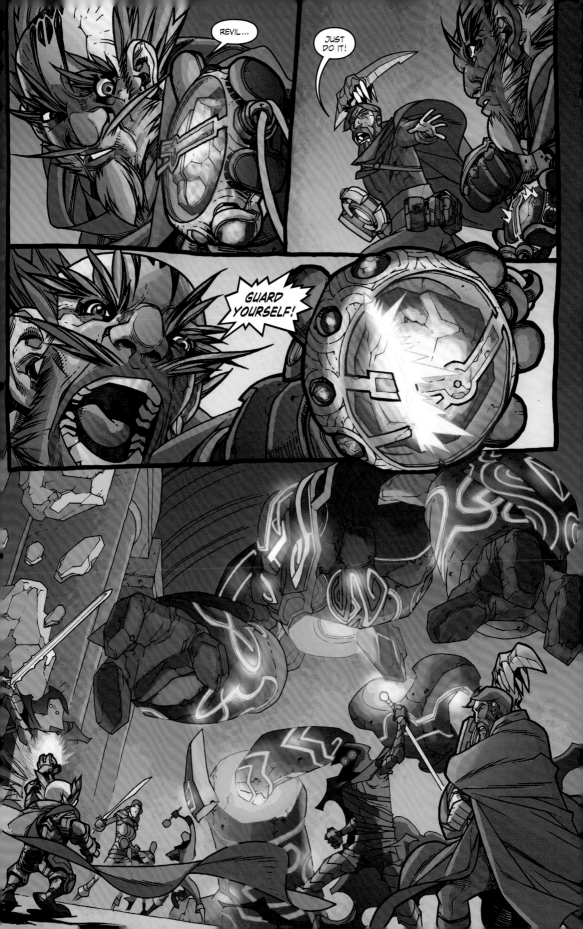

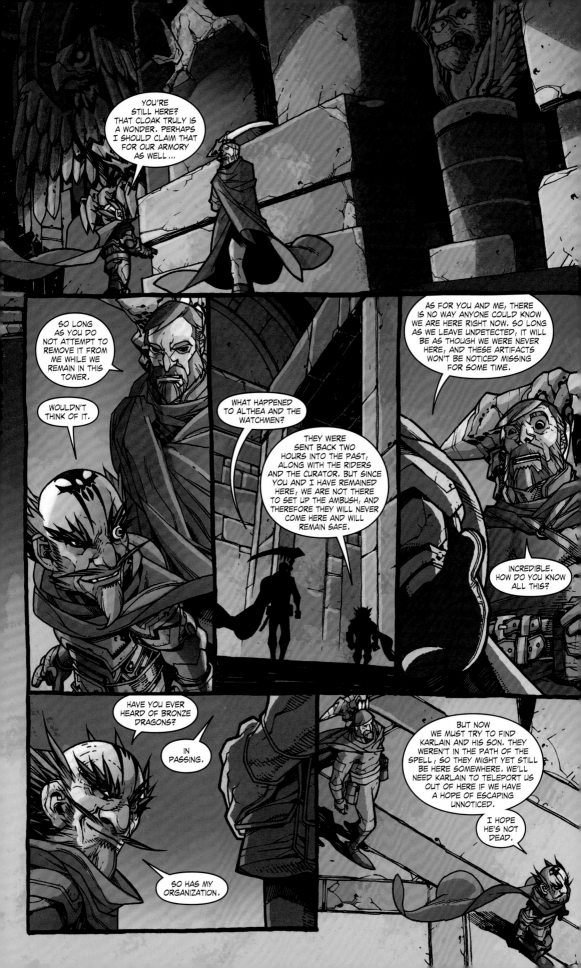

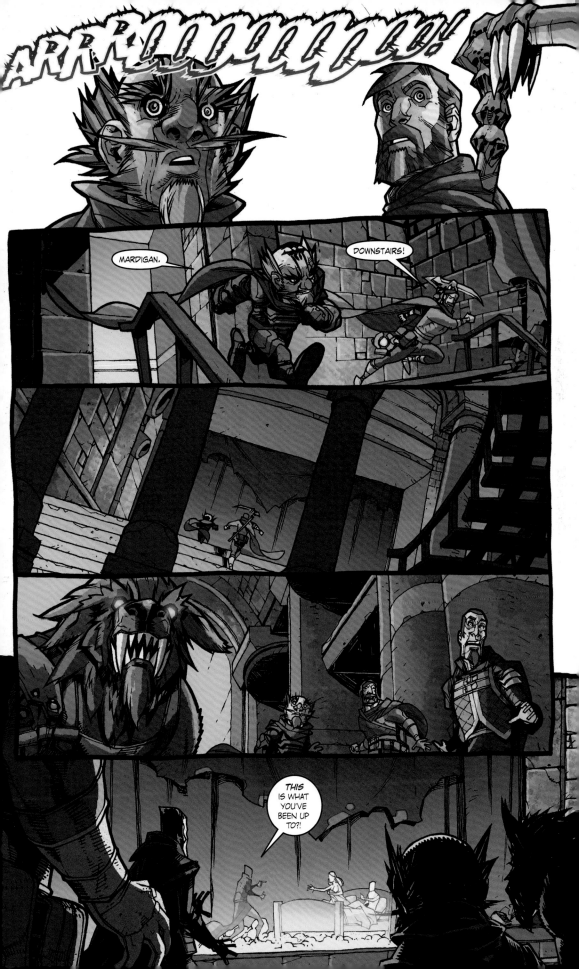

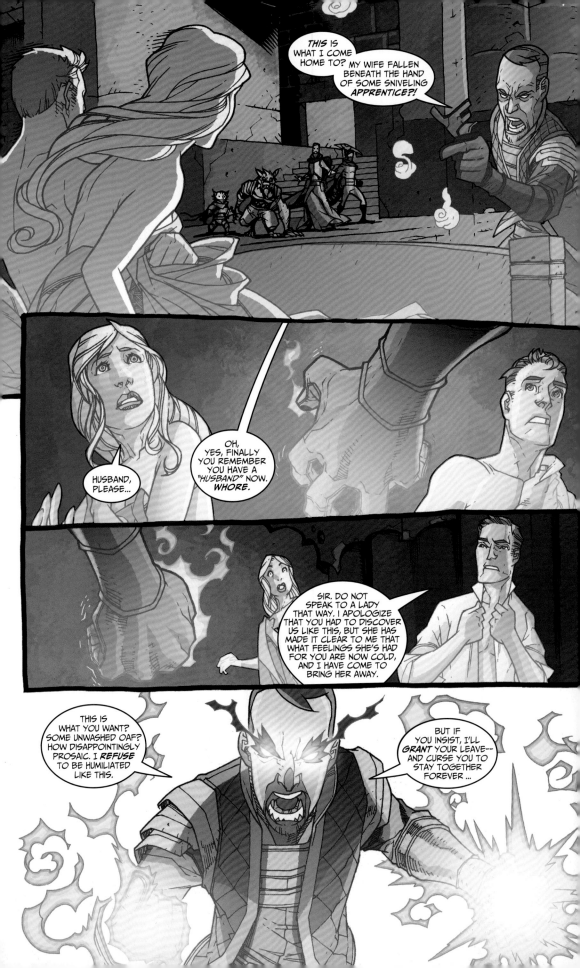

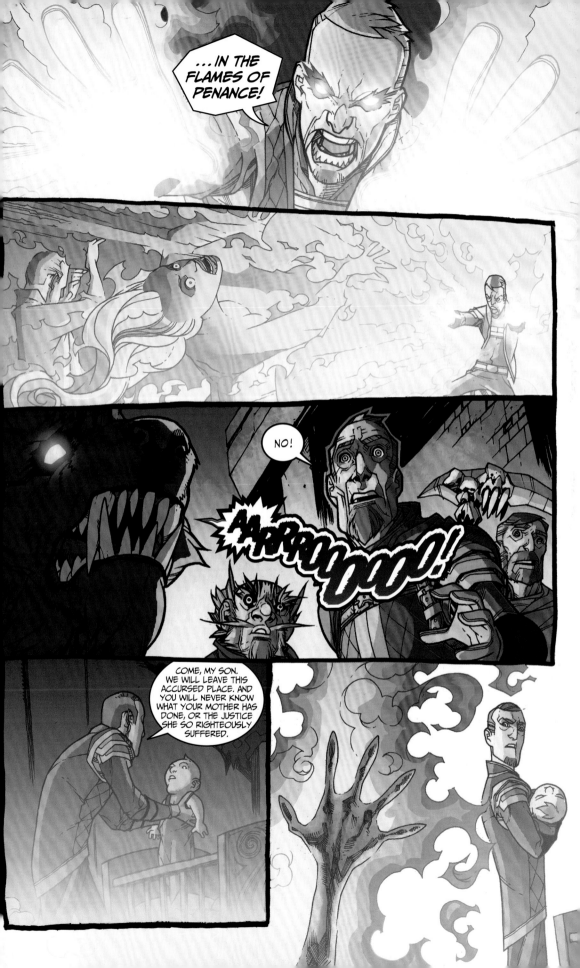

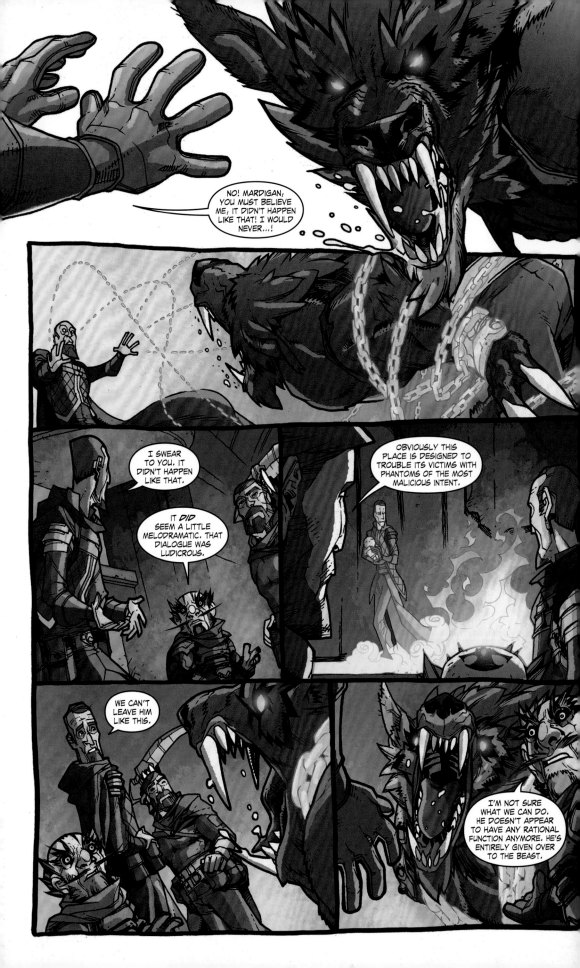

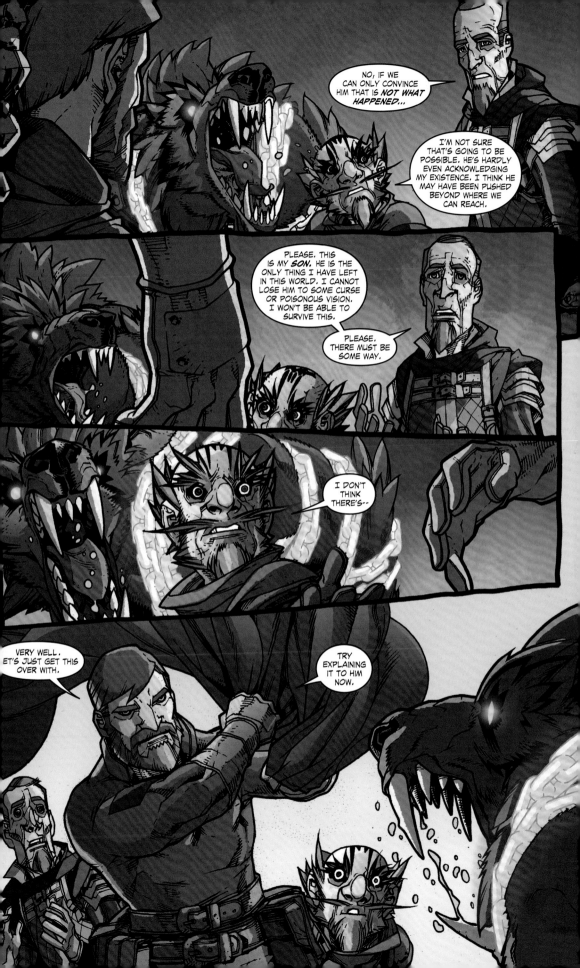

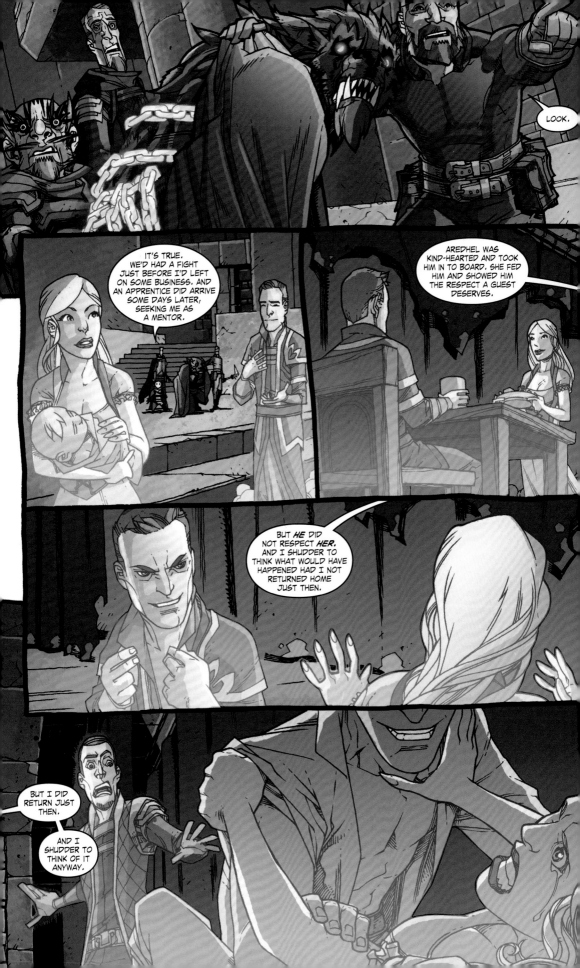

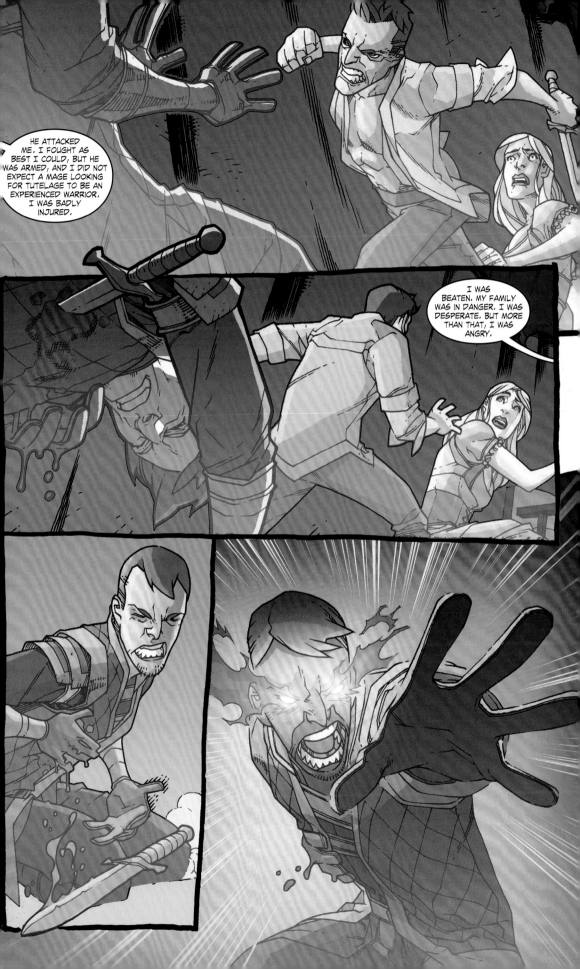

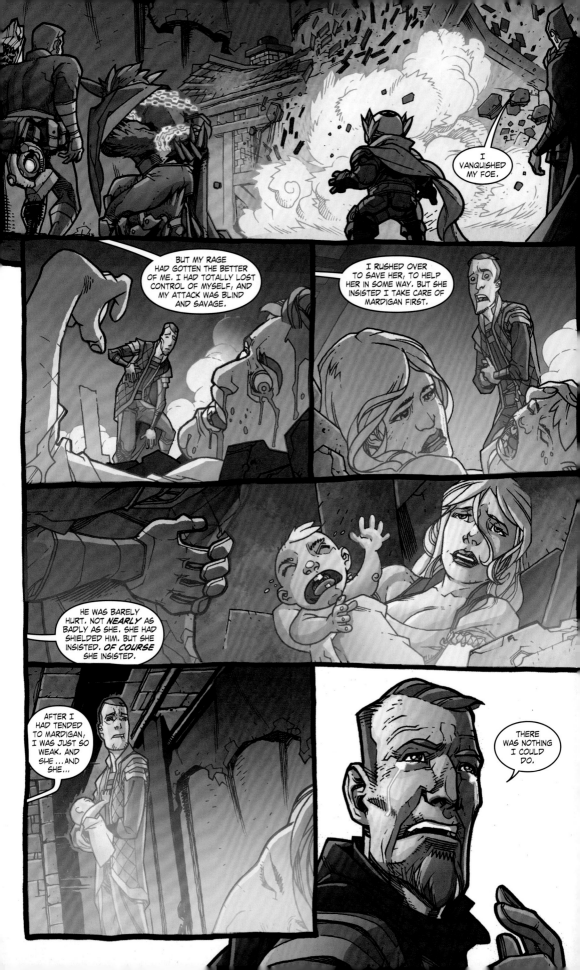

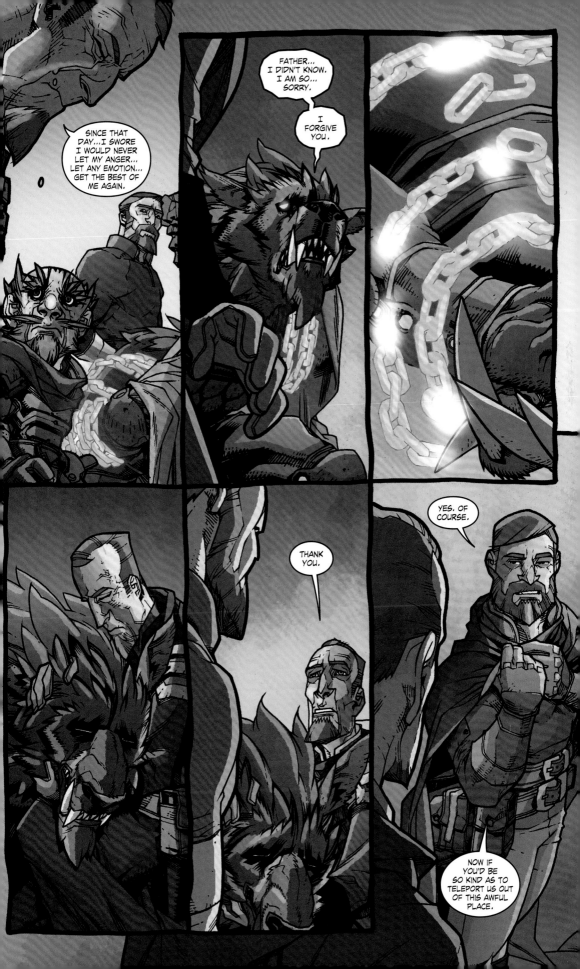

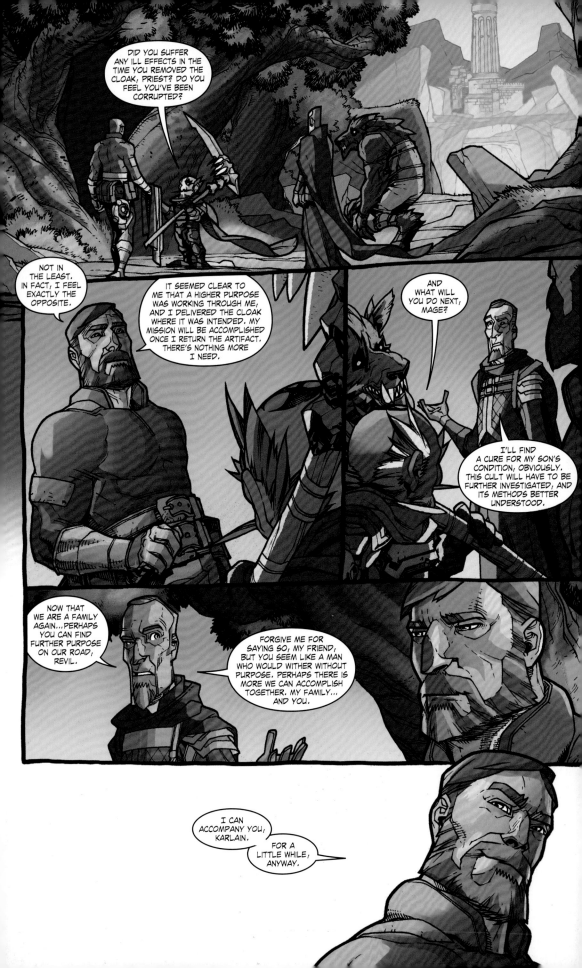

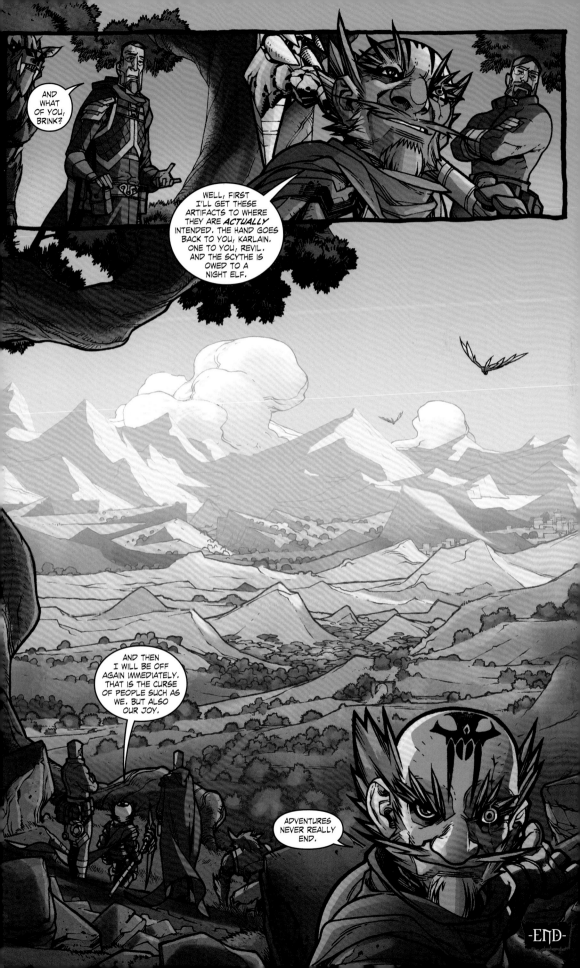

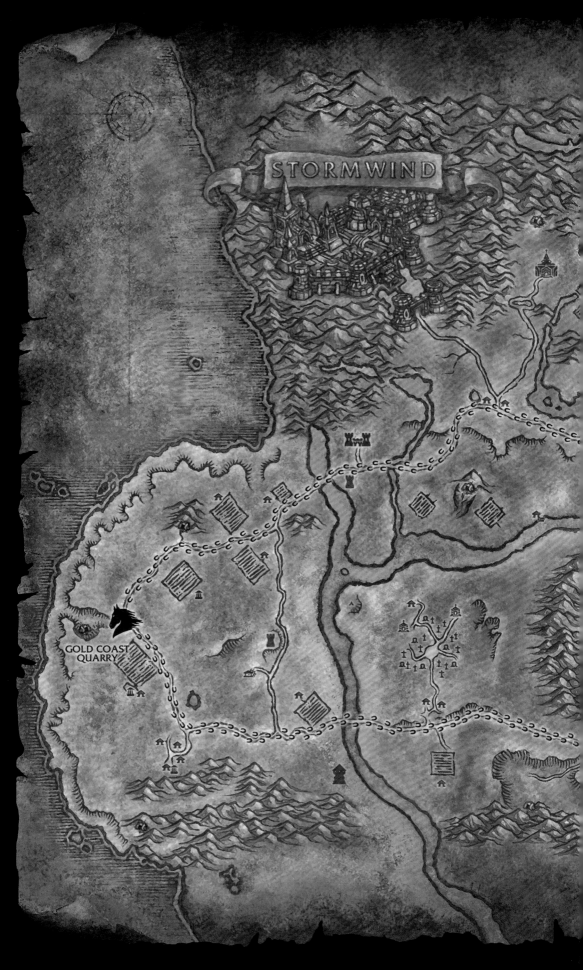

STORMWIND

GOLD COAST
QUARRY

PATH OF THE DARK RIDERS

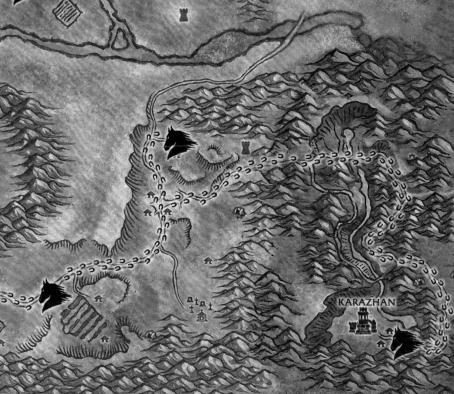

LEGEND

 DARK RIDERS SIGHTED

 SUSPECTED ROUTE

TOWER OF
AZORA

KARAZHAN

WORLD OF WARCRAFT: DARK RIDERS

was initially developed as a miniseries, but was transformed into a longer, single book in order to add more depth to the story and give the artists more time. Several beautiful covers were commissioned for the miniseries before the switch...some shared here for the first time!

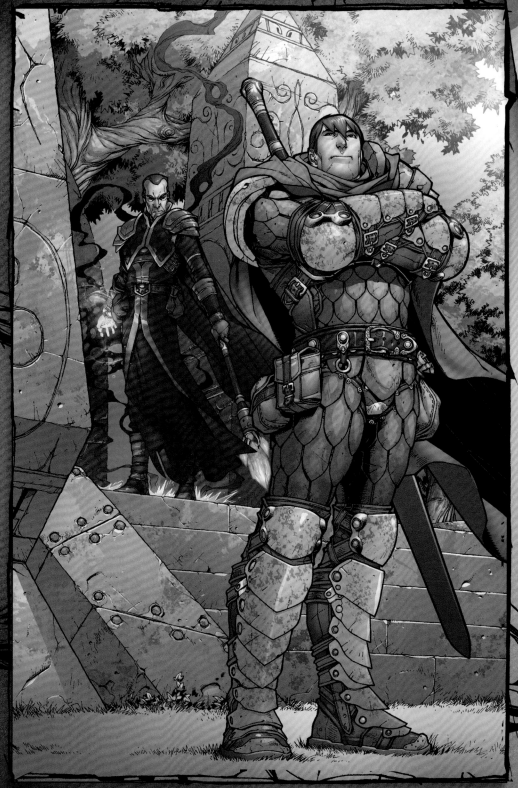

Art by Neil Googe, colors by Jonny Rench. This stunning cover shows Karlain and his son Mardigan. As it was our first look at these characters, a close eye reveals some small character design differences from the final versions.

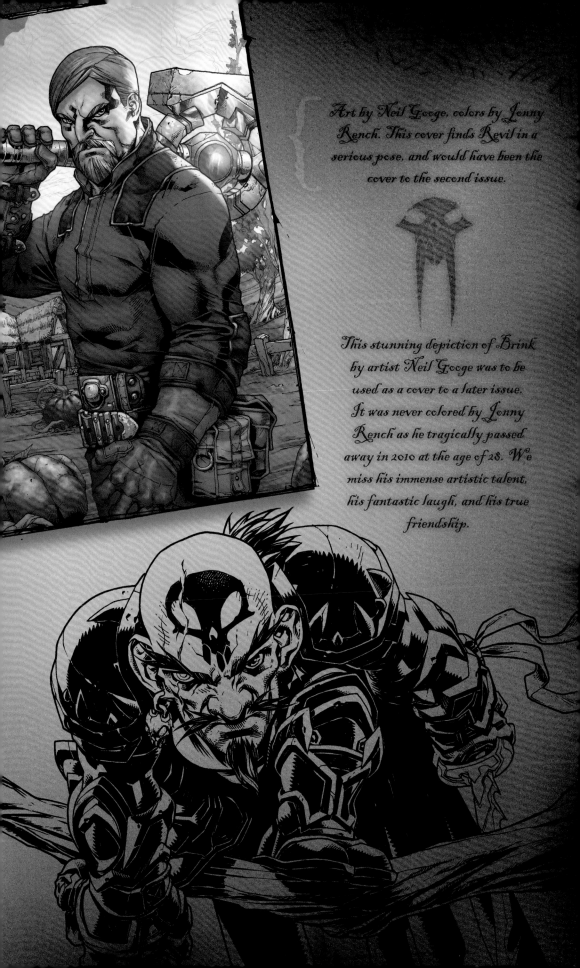

Art by Neil Googe, colors by Jonny Rench. This cover finds Revil in a serious pose, and would have been the cover to the second issue.

This stunning depiction of Brink by artist Neil Googe was to be used as a cover to a later issue. It was never colored by Jonny Rench as he tragically passed away in 2010 at the age of 28. We miss his immense artistic talent, his fantastic laugh, and his true friendship.